reel life
lessons

...so far

RICO RODRIGUEZ

with laura morton

reel life
lessons

...so far

A CELEBRA BOOK

CELEBRA
Published by New American Library, a division of
Penguin Group (USA) Inc., 375 Hudson Street,
New York, New York 10014, USA
Penguin Group (Canada), 90 Eglinton Avenue East, Suite 700, Toronto,
Ontario M4P 2Y3, Canada (a division of Pearson Penguin Canada Inc.)
Penguin Books Ltd., 80 Strand, London WC2R 0RL, England
Penguin Ireland, 25 St. Stephen's Green, Dublin 2,
Ireland (a division of Penguin Books Ltd.)
Penguin Group (Australia), 250 Camberwell Road, Camberwell, Victoria 3124,
Australia (a division of Pearson Australia Group Pty. Ltd.)
Penguin Books India Pvt. Ltd., 11 Community Centre, Panchsheel Park,
New Delhi - 110 017, India
Penguin Group (NZ), 67 Apollo Drive, Rosedale, Auckland 0632,
New Zealand (a division of Pearson New Zealand Ltd.)
Penguin Books (South Africa) (Pty.) Ltd., 24 Sturdee Avenue,
Rosebank, Johannesburg 2196, South Africa

Penguin Books Ltd., Registered Offices:
80 Strand, London WC2R 0RL, England

First published by Celebra,
a division of Penguin Group (USA) Inc.

First Printing, November 2012
10 9 8 7 6 5 4 3 2

Unless otherwise noted, all photos are courtesy of the author. Photos on pages ii, ix, 1, 9,
23, 35, 59, 71, 85, 95, 107, 117, 127, 137, 151, 161, 169, 183, 193, 207, and 212 are courtesy
of Zach Cordner.

CELEBRA and logo are trademarks of Penguin Group (USA) Inc.

LIBRARY OF CONGRESS CATALOGING-IN-PUBLICATION DATA:

Rodriguez, Rico, 1998–
Reel life lessons . . . so far/Rico Rodriguez with Laura Morton.
p. cm.
ISBN 978-0-451-23765-1
1. Rodriguez, Rico, 1998– 2. Actors—United States—Biography. 3. Actors—Family
relationships—United States. I. Morton, Laura, 1964– II. Title.
PN2287.R7173A3 2012
791.4302'8092—dc23 2012024158
[B]

Set in ITC New Baskerville STD
Designed by Pauline Neuwirth

Printed in the United States of America

PUBLISHER'S NOTE
Penguin is committed to publishing works of quality and integrity. In that spirit, we are proud
to offer this book to our readers; however the story, the experiences and the words are the
author's alone.
 While the author has made every effort to provide accurate telephone numbers and
Internet addresses at the time of publication, neither the publisher nor the author assumes
any responsibility for errors, or for changes that occur after publication. Further, publisher
does not have any control over and does not assume any responsibility for author or third-
party Web sites or their content.
 The recipes contained in this book are to be followed exactly as written. The publisher is not
responsible for your specific health or allergy needs that may require medical supervision.
The publisher is not responsible for any adverse reactions to the recipes contained in this
book.

To God and my loving family

contents

contents

living
the
dream

most of you probably know me from playing the very lovable Manny Delgado on the Emmy-winning ABC comedy *Modern Family*. On the show, my character, Manny, is the only son of Gloria, played by the amazing and beautiful Sofia Vergara, a hot-tempered Colombian beauty who married the considerably older Jay, played by the incredibly talented Ed O'Neill.

I didn't meet the *Modern Family* cast until after I got the part of Manny. It's a little embarrassing to admit, but I didn't even know who Ed and Sofia were at first. Maybe this was a blessing in disguise, because *if I had known*, I would have been really nervous.

When my dad got the call that I was being offered the role, he said, "Do you know who you're going to be working with, Rico?"

I didn't have an answer.

"Ed O'Neill!" my dad said all excited.

I had no idea who he was talking about.

My dad started singing, "'Love and Marriage—love and marriage...'"

Nope. I still had no idea who he was talking about.

The first time I met Ed, I told him that story. And he said he understood. After all, I was just a little kid. How would I know about *Married...with Children* when it was on TV before I was born? From that day on, I realized I was in very good hands with Ed. I felt comfortable with him and the rest of the cast from the very start.

Being on MODERN FAMILY feels like gaining a second family. I guess you can call them my REEL family as opposed to my real family. Real or reel, both of my families feel right to me.

Being on *Modern Family* feels like gaining a second family. I guess you can call them my REEL family as opposed to my real family. Real or reel, both of my families feel right to me. The reel family is different from the one I'm growing up in but feels like my real family, because of the laughs and support we all share together. I know that my TV parents, played by Ed and Sofia, have my best interests at heart, much like my own parents do. I love pranking and fooling around with my TV nieces and nephew just like I do with my real nieces and nephew at home. It's a really cool feeling to know I have both a reel family and a real family to call my own.

Many people have asked me if I am as suave and mature as Manny in person. The obvious answer is...

Yes!

Okay, the truth is, we aren't really all that alike. While Manny is still very much a child, he conveys a very mature spirit. He sips espresso, favors a burgundy velvet dinner jacket, and often dispenses philosophy to adults about love and marriage. He could best be described as a forty-five-year-old man trapped inside a thirteen-year-old boy. He reads Shakespeare, and he is a hopeless romantic and wise beyond his years.

Still, Manny and I do share some things in common. For example, we both have nieces and a nephew. I'll even admit that like Manny, I enjoy a little bit of classical music every now and then. But stuff like writing love notes and poetry—I don't do any of that. And drinking espresso is really hard for me because I think it's kind of gross. Besides, the cups are so small, you hardly get anything in

living the dream

there! I'm more of an ICEE or tall-glass-of-milk kind of guy.

Manny likes to write poems, while I'd rather be watching *Star Wars*. He likes to read Shakespeare, and I like to read books like *Diary of a Wimpy Kid*. He really wants a girlfriend, and I would still rather be playing with my video games. Manny is so mature, and frankly, I am not. Do I think Manny and I would be friends in real life? Well, that's easy—yes. And, when the time comes, he would be able to help me with the ladies because he's such a ladies' man.

Despite our many differences, there are a couple of things Manny and I do share in common. We both have lived a lot of life in our extremely limited years. We are both enthusiastic, dreamers, risk takers and unafraid to face challenges that may come our way.

reel life lessons . . . so far

But for the most part, I am just a regular kid blessed with a loving and supportive family who hails from the great state of Texas—College Station, to be exact, the hometown of Texas A&M University, home of the fighting Texas Aggies. Despite our many differences, there are a couple of things Manny and I do share in common. We both have lived a lot of life in our extremely limited years. We are both enthusiastic, dreamers, risk takers and unafraid to face challenges that may come our way. And because of the strength we find in our family bonds, we have the support to do and become whatever we wish to be.

Whether through Manny or by just being myself, making people laugh is the greatest feeling in the world.

I love to entertain people and make them laugh. Whether through Manny or by just being myself, making people laugh is the greatest feeling in the world. I started this journal so I could always remember this amazing time in my life. And as I began writing my journal, I also realized how many real-life lessons—and reel-life lessons!—I'm learning. I'm really excited to share some of them with you!

I hope you enjoy coming along for the ride that has been my life...so far.

Here I am goofing around on Santa Monica Pier.

everything
happens
for a
reason

when my sister, Raini, was eleven years old, she told my parents that she wanted to be an actress. This wasn't news to anyone, as Raini was always singing and putting on performances. In fact, when she was a toddler, Raini did a pageant and was a natural performer. Needless to say, she loved being onstage, and I guess you could say that Raini just knew she wanted to act.

As for me, I was a terribly shy little boy. I was that kid who was always hanging on my mom's pant leg, hiding behind her and avoiding eye contact with anyone I didn't know.

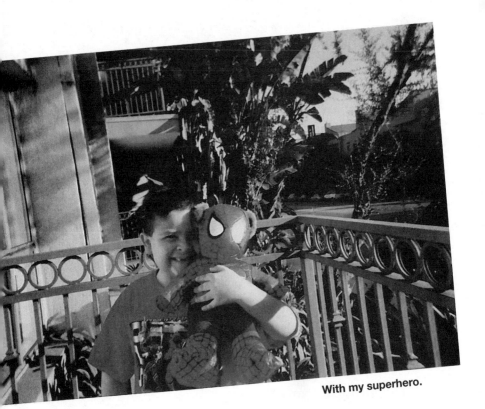

With my superhero.

My parents are the type of people who will move mountains for their children, especially if that is what it would take to help us achieve our dreams.

My parents are the type of people who will move mountains for their children, especially if that is what it would take to help us achieve our dreams. But they're also practical people too. They would never make a rash decision, especially one that could potentially have an impact on our family, without really thinking it through. My mom and dad knew that if Raini was going to make a real go at becoming a professional actress, they were going to have to make the difficult decision to relocate our family to Los Angeles because that's where most of the auditions are. Before they would make the move, they wanted to be sure that Raini really wanted this more than anything. To test her, every time Raini brought up acting, my dad would say something like "Why don't you wait a few days and think about this? Go read a book, spend some time at the mall with your girlfriends or watch a movie," thinking she would just forget about it.

But Raini never gave up.

Never.

I think that kind of determination is one of the best Rodriguez family traits, because none of us can be budged from our position if we really believe in something.

everything happens for a reason

I think that kind of determination is one of the best Rodriguez family traits, because none of us can be budged from our position if we really believe in something.

Of course, acting lessons cost money—extra money my parents didn't have. So my mom and dad found a way to come up with the extra cash by working longer hours at the family tire shop—selling more tires and such, all so my sister could take acting lessons.

In January 2005, Raini and Mom and Dad went to a talent showcase in Los Angeles. Raini went through a process of auditions that gives you opportunities to get in front of different groups of agents and managers. One of the auditions was a monologue. Raini waited her turn in a line that ran along the entire wall of the conference room in the Bonaventure Hotel in Downtown Los Angeles.

When it was Raini's turn to audition, she stepped onto the stage in front of the judges, who included agents and managers looking to sign new talent. Raini's monologue was a scene that took place in a casino, so she placed a chair in the middle of the stage, sat down in the chair and started her scene. It seemed like a lot of the agents and managers were tired because it was the end of a long day of auditions and most of the judges were done for the day. Raini noticed that they were starting to rest their heads in their hands and rub their eyes. So she gave it her absolute best show and put out as much energy as possible. Raini wanted to make her time onstage count.

One of the managers watching was Susan Osser. Susan later told Raini, Mom and Dad that she was very impressed

by Raini's performance and saw a lot of potential. She understood that Raini was new to the industry but believed that with more training and acting classes, she could help take Raini's career to the next level. Since our family didn't live in Los Angeles, it was going to be a real test if Mom and Dad wanted to give Raini the best shot possible. Susan went on to say that we needed to move to Los Angeles for no less than a year to do that.

After Susan gave Mom and Dad her information, my parents and Raini returned to Texas to discuss how to move forward. Mom and Dad made the choice that if they wanted to give Raini a real opportunity to break through in acting, they were going to have to make the move. It was going to be hard on our family, especially on my dad, who would probably have to stay behind to run the family's tire business.

Although it required a tremendous amount of faith and a lot of sacrifices on their part, my parents agreed that if just one person showed interest in Raini, then it would all be worth it. So, in early 2005, my parents made the final, difficult choice that Mom would take Raini and me to Los Angeles for a year while dad stayed back in Texas to work at the tire shop and support our family.

Things were very slow in the beginning. Raini would go on auditions for commercials here and there, but then there would be weeks and sometimes even a month or two in between new opportunities. There were moments when my dad thought it might be time for us to come home— that Raini had given it her best shot. Still, my sister wasn't

ready to give up her dream. Mom, Raini and I would sit around the kitchen table, giving one another a family pep talk that always ended in a collective decision to stay and keep trying.

"If it isn't meant to be, then the good Lord won't make it possible," Mom often said.

I believe my parents knew there were going to be struggles along the way, but they never let their fear or angst interfere with Raini's enthusiasm and determination.

I believe my parents knew there were going to be struggles along the way, but they never let their fear or angst interfere with Raini's enthusiasm and determination. Whenever Dad would come to visit those first few months, he'd always say, "I can still book three more flights home with me if you're ready to come back to Texas!"

My mom and dad were very clear to let us know that whenever we were ready to leave L.A. and live a normal life, it would be okay with them. There was no pressure either way—just constant love and support.

Once we finally got settled, we went over to Susan's office. It was the first time I'd met her, and I was incredibly

shy. I kept hiding behind my mom as she tried to introduce me to Susan. Susan explained that Raini was going to have to interview with agents to see which ones she felt comfortable with. When the meeting was finished, we got up from the table and walked to the door to leave.

I find that anytime my parents have given me the option of making my own decision along the way, I often choose the path they would want me to take anyway.

What I didn't know then was that Susan told Mom that I had the cutest face and that I might want to try out for acting too. Susan explained that she had found that the siblings usually see all the fun the other one is having in the acting classes, and so they want to be having that fun too. Susan

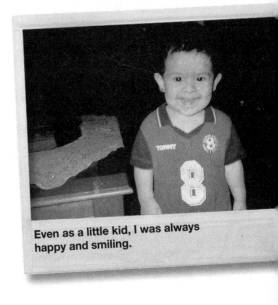

Even as a little kid, I was always happy and smiling.

knew it would be in my best interests to sit in and watch what the other kids were doing in the acting class. If nothing else, it would help me break out of my shyness.

Mom thought it was a good idea as well, so Susan called her acting coach to tell her that I was going to hang out in the acting classes. They weren't going to ask anything of me but were just going to wait patiently until I made the first move and decided to join in. I find that anytime my parents have given me the option of making my own decision along the way, I often choose the path they would want me to take anyway. That's a clear tribute to them as parents because they've equipped me with the ability to make the right decision for myself, something they can rest easy knowing as I grow and move on in my own life. Breaking out of my shell didn't just happen, though. It would be quite a road to get there.

> Breaking out of my shell didn't just happen, though. It would be quite a road to get there.

The acting teacher was happy to let me sit in, and after only a couple of classes, I wanted to join the fun. Raini already had an agent and started going on auditions. When she had sides to memorize for her auditions, she would practice her lines with me. I started really enjoying the entire process.

> If I were given the choice of being
>
> a superhero, I'd definitely want to
>
> be Spider-Man with Superman's
>
> superpowers, like his ability to fly,
>
> his laser vision and his ability to
>
> read minds.

Eventually, I started getting my own copies of the sides to study in class. After that, I told Mom and Susan that I wanted to go on auditions too. At the time, I loved Toby McGuire, especially his work as Spider-Man. I was a five-year-old boy, and Spider-Man was still my superhero. If I were given the choice of being a superhero, I'd definitely want to be Spider-Man with Superman's superpowers, like his ability to fly, his laser vision and his ability to read minds. Spider-Man's webs are cool, but if there are no buildings to cast his webs upon, he can't fly like Superman. I also love Batman because he is the ultimate-fighter dude. He is an expert in self-defense, so I'd also like to have his skills. With all of this fantasy about superheroes, it suddenly made complete sense to check out acting. Boy actor by day, and crime-fighting superhero by night! I liked the way that sounded!

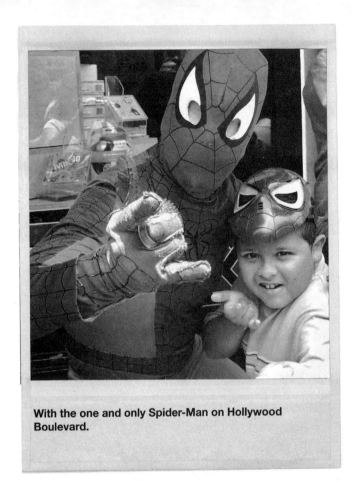

With the one and only Spider-Man on Hollywood Boulevard.

Susan explained to us that acting would help me to open up as a person and give me the courage to find myself as a young man. Acting might or might not end up being my calling, but the experience of taking those classes would definitely help me grow out of my shyness. I learned how to tap into all of my different emotions, and I gained a tremendous amount of confidence through the experiences. In many ways, I went in feeling like the cowardly lion from *The Wizard of Oz*, who was looking for courage and discovered it was inside him the whole time.

> To me, courage is taking a chance
> and finding a way to make the
> best of whatever situation you
> find yourself in.

To me, courage is taking a chance and finding a way to make the best of whatever situation you find yourself in. Whenever I think I can't do something, I go inside myself to find the strength and will to persevere anyway. I think courage is true faith. Someone once told me that babies are born with two fears—the fear of falling and the fear of loud noises—so everything else we grow up fearing is actually learned. While my fear of spiders, snakes, bees and scorpions is justified, my fear of failure is not. I mean, what's the worst thing that could happen?

I try. I fail.

So what?

No harm, no foul, right?

Acting has given me the strength and self-belief that I cannot only try anything, but most of the time, I can do it!

> Acting has given me the strength
> and self-belief that I cannot only
> try anything, but most of the
> time, I can do it!

everything happens for a reason

Dear Journal,

And to think in the beginning, I didn't want to move out to L.A. I guess things do happen for a reason.

if you
can sell
cheetos
and ice
cream,
you can
conquer
the world!

eight months after sitting in on my

first acting class with Raini, Susan told Mom

that she thought I was ready to go on audi-

tions. I officially became Susan's next client.

The first "audition" that Susan set up wasn't

actually for a job but to get an agent. That's

when I met Philip Marcus, Bonnie Ventis,

and Jody Alexander or, as their clients like

to call them, PB&J. The agents wanted to

meet me to see my personality and to see if

I could take direction.

I knew the agents had fallen in love with Raini and im-
mediately signed her when she went in front of them to

audition, but I didn't know how they would feel about me. One thing was for sure: Raini wasn't the only one who had officially been bitten by the acting bug. I was getting pretty comfortable with the process and the idea of working as an actor. The more I worked, the clearer it had become that my destiny was right in front of me.

My classes continued to go well, and I became more and more comfortable performing in front of people. Once I overcame my shyness, I realized that I had the natural ability to make people laugh.

Having fun on set.

reel life lessons ... so far

When I got into the room, PB&J asked me to describe my favorite food.

"I like spaghetti! Because, well, I do. It really is my favorite food—especially my mom's. Well, my dad's too. I can't decide. They are both great!"

Next, they asked me what I liked to eat for dessert.

So I told them: "Vanilla ice cream with Cheetos sprinkled over the top."

Jody said, "Great. Can you tell me that like you're doing a commercial? You see that plant on the corner of my desk? Pretend that's a camera and talk right to it."

"If you love vanilla ice cream, you will flip for this new awesome dessert! It's the perfect mix of sweet and salty: vanilla ice cream with Cheetos on top. Mmmmm. Yummy!" And then I gave a great big smile.

You see, one of my most beloved family traditions is eating ice cream for dessert. In our family, however, we add one extra special twist to that tasty treat...Cheetos.

Yeah, you read that right.

I know. It sounds pretty gross, but trust me—it isn't.

To properly eat this family favorite, you don't crumble the Cheetos, and you don't dip them in the ice cream. After years of experimenting, I have found the very best way to enjoy this dessert is to place whole Cheetos on top of a single or double scoop of vanilla ice cream and smooth them in. Once they are mixed in, you crush them with your spoon.

Now, you might be wondering if any good can come from eating this crazy concoction—and the answer is... yes!

cheetos and ice cream

I must have done a great job because PB&J laughed out loud and signed me on the spot. When I first told them about our family recipe, I am pretty sure that no one in the room had ever heard of this combination, but you can bet they all went out and tried it. The agents loved my mouthwatering description.

And isn't that what life is all about? You know, trying new and interesting things that might sound strange or odd at first but end up being the absolute best discovery!

My agents set up three auditions for me. I was really nervous when I went on my first "official" audition, which was to be a part of a cheering crowd at a baseball game. My mom and I walked into the room, signed in, sat down and waited for them to call my name. When they did, I pulled my mom's hand to come with me.

"C'mon, Mom. Let's go."

"Rico, I can't. Remember you have to go in by yourself," she replied.

"Oops. I forgot that part." I said.

I had never been on an audition, let alone gone into a room with people I didn't know without my mom with me. I got real shy and began to cry. Let's just say this wasn't my finest hour. In fact, my eyes were so red, I didn't want anyone to see me. I stuck it out and did the audition anyway because I really wanted to give it a shot. All I was asked to do was to scream like a cheering fan of my favorite sports team—but I couldn't do it. I just couldn't muster up the emotions to act like a cheering fan. Needless to say, I didn't book that role, but that ex-

perience helped me to realize that I would have to over-come my shyness so I could tap into whatever emotions I had to at any time. This made me a lot better prepared for my next audition.

Needless to say, I didn't book that role, but that experience helped me to realize that I would have to overcome my shyness so I could tap into whatever emotions I had to at any time.

My dad happened to be in L.A. that day, but thinking he was in Texas, Susan called him and said, "Mr. Roy, are you sitting down because I have some great news to tell you. Rico just booked three auditions in a row!" I had just signed with my agent, so I think everyone was excited over the good news, especially me. I screamed three times with joy—once for each job. (If only I had been able to do that the first time, I probably would have booked my first FOUR jobs!)

> We are an incredibly close-knit
> family, and the distance was hard
> on all of us.

With Mom, Raini and me living in Los Angeles, the situation was tough on Dad because he missed us so much. We are an incredibly close-knit family, and the distance was hard on all of us. Fortunately, Susan and PB&J would regularly call him on the phone to keep him informed of everything that was going on.

It was a great way to keep Dad connected with everything that was happening with our careers. Whenever Raini or I got a callback, they would make sure Dad was one of the first people to know about it and let him tell us the good news. Dad would then call and ask, "So, how did it go? How do you feel you did?" He had a lot of fun with it. Then he'd say, "Maybe if you are not doing anything tomorrow, you could go on a callback!" At that point, we would all start yelling wildly. We were so happy. That became the way of our team letting us know that we had a callback or had booked a job. "Team Rodriguez" was now in full swing!

> My greatest achievement has not
> just been facing, but overcoming,
> my fears.

reel life lessons . . . so far

Ever since then, we've made it our tradition for my manager or agent to call my dad first for each audition I booked. I've heard stories about athletes who won't change their socks during the play-offs or who carry a good luck coin in their pockets during a game because they believe that doing the same thing over and over will bring them good luck. Well, that's how I feel about my dad getting the calls first. So far, this has really worked!

My parents don't make a big deal out of anything. We go in, do our auditions and then go about our day trying not to think too much about the outcome.

On the one-year anniversary of moving to Los Angeles, Raini was called back for a final audition for Maya, one of the lead roles in the feature film *Paul Blart: Mall Cop*. My dad happened to be in L.A., to spend Valentine's Day with my mom, so he drove Raini to meet with the star of the movie, Kevin James, at his office for her audition. Just before she went in, my dad turned to her in the backseat of his car and said, "You just go in and do what you do. Do your best. No matter what happens, you will always be a star in my eyes. And, if this doesn't work out for you, we

will wait for the next one." My parents don't make a big deal out of anything. We go in, do our auditions and then go about our day trying not to think too much about the outcome. Any other approach is too emotionally draining. Raini and I hope for the best yet prepare for the worst. We both know that something will eventually come through. And this time, for Raini, that's just what happened. She got the part of Mr. James's daughter, Maya Blart, which became her first breakthrough role and her first major motion picture. I was so proud of her and very happy for her achievement. That was the best Valentine's Day ever!

Me on *Jimmy Kimmel Live* playing a prank on Uncle Frank.

reel life lessons ... so far

We are a family who supports one another 100 percent.

We are a family who supports one another 100 percent. We celebrate the victories just as we console one another when things don't necessarily work out. That's how we get through everything—together—as a unit.

cheetos and ice cream

sometimes
a modest
family can
make you
feel like
the richest
person

my parents were young and in love when they got married. They said they always knew they would be together forever. They had their first son, my oldest brother Roy Jr., by the age of twenty. Shortly thereafter, they had their second son, Ray. As new parents, they were doing their best to make ends meet. My dad worked as an air-conditioning repairman and a baker making bread and pastries at a local cafeteria while attending college. Mom was a hairstylist but never wanted to make a living at it. She mostly

cut hair for family and friends. After a couple of years of trying to find their way, my parents knew they had to make some changes so they would be able to properly provide for their family.

> My mom and dad have said they
> always knew they would be
> together forever. They were young,
> in love and doing their best to make
> ends meet.

That's when they decided to go into the tire business. At the time, things were incredibly hard on my parents. To get the business off the ground, they had to pawn everything of value they owned, including their wedding rings! On one occasion, although Mom and Dad had paid all of their bills for the month, they only had enough cash left over to buy a single hamburger to split between them for dinner. My dad was too proud to ask anyone for help. He didn't want anyone to know how badly they were struggling. Mom had so much confidence and trust in him that she never complained. In fact, she told him she'd live in a cardboard box with him if she had to as long as they were together. Thirty days later, Dad had enough money to get their wedding rings back and the business was on—the wheels were rolling.

reel life lessons ... so far

They opened their first Rodriguez Tire Service shop twenty-five years ago in Bryan, Texas. They painted the exterior of the shop red, white and blue, making it easy for customers to spot. Owning that tire shop was a full-time commitment that required them to be at work every

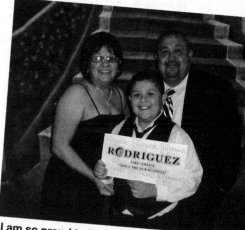

I am so proud to be a part of my family business, which my parents started in 1983.

day no matter what. This even meant bringing my older brothers with them at first and then my sister, Raini, and me as we came along. You might say we all literally grew up in the back of the family tire store.

While they were getting the business off the ground, to conserve money, my parents converted one of the three bays where they changed tires into a small apartment where they lived for a year. This was before I was born, but the story lives on in our family as one of the most important lessons I grew up hearing. In life, you will have to make sacrifices to take care of your family. My parents have never wavered from that philosophy, especially later on when it came to supporting my sister and me in our budding acting careers.

My parents knew they had a good business and operated their store very lean and mean. My father stayed open three hundred, sixty-four days a year. The only day he ever closed the shop in those early days was on Christmas. The store was their bread and butter. If they weren't

open, someone else surely was. Therefore, the other store was getting that business, which meant the owners were making money, and my parents weren't. And, at the time, they really needed the money. Without income, they wouldn't be able to provide for their family. Plus, my dad knew people traveled on holidays, and if they happened to get a flat tire or if they got stranded, there needed to be someone who could take care of them. My parents were, and continue to be, those people.

There came a time when Dad knew that he was going to have to buy his own building. Eventually, he was able to save enough money to buy a building that had three stalls for working on cars. The home they had been living in was very far from their new building. My parents needed to be close to the business, so they decided to take one of the work stalls and turn it into an apartment. A nearby building that had been recently torn down was built out of cinder blocks that were perfect for constructing the apartment. Dad was given permission to take whatever he needed but would have to clean off the blocks by hammering off the old excess mortar.

Mom and Dad would take Ray, Roy Jr. (whom we call Poppi) and Raini to school in the morning and be back at the shop to open by eight a.m. At the end of the school day, they'd pick everyone up and have them do their homework at the shop. Of course, the kids were always hungry when they came home from school, so Mom would fix them something to eat. Over time, Mom and Dad fixed up the stall they turned into an apartment and bought a

reel life lessons ... so far

refrigerator and a hot plate to cook on so they were able to make simple and inexpensive meals in their makeshift kitchen. Whenever Mom cooked, the customers would smell the food and wonder where it was coming from. Mom's cooking is so good. I think they could have started a second business called "Tires and Tacos"!

After years of working really hard, my parents were finally able to buy fifteen acres of land in the countryside, where they put a mobile home on the property. By this time, Mom was pregnant with me. Trust me, the mobile home wasn't big or fancy—but it would be theirs. Dad got a really great deal on the mobile home because it was infested with bugs. They didn't have the extra money to spend on an exterminator, so Dad parked the mobile home in the heat for about month and let nature take its course.

The land they bought was completely undeveloped, which meant they would have to bring in water, electricity and even plumbing! When they had finally saved an extra fifteen hundred dollars, they were able to get electricity, but they still had no running water. They went to my dad's parents' home in town every night to bathe and use their bathroom. You see, even though they had electricity, they still had no plumbing. In fact, the only bathroom my sister used at that house those first few years was the great outdoors. Family legend has it that Raini potty-trained herself. One day, she ripped off her diaper and never looked back. My mom always tells a great story about a woman who came to see their property one day. When she asked to use the restroom, Raini said, "I'll show you" and

promptly opened the back door. In Raini's mind, that was the only place to go! Mom said the woman seemed confused until she was able to explain they didn't have plumbing yet. The woman didn't use our bathroom that day. Thankfully, shortly thereafter and a couple of hundred dollars later, they were finally able to install a septic tank and put in the proper plumbing so they could have all of the comforts.

As our family's tire business improved, my parents were able to build around the mobile home. What started as a regular-looking mobile home eventually became a house that looked like anyone else's because my parents built several additions until the original mobile home was completely unrecognizable!

Once I was old enough to go to school (I was only in preschool and kindergarten), Mom would pick Raini and me up and let us stop by Hot Dog Etc., one of our favorite fast-food restaurants, to get something to eat after school. When we got home, we usually watched two of our favorite television shows at the time, *Boy Meets World* and *Sister, Sister.* After they ended, we did our homework. To be totally honest, I'm not sure I actually had any homework back then because I was only five years old, but my mom sure tried to keep me busy while Raini did hers. At that time, I guess coloring felt like homework!

Dad usually got home around seven p.m. after closing up the tire shop for the day. My sister and I would run out and meet him after he pulled into the driveway. He might have been tired from his day of work, but he still had

enough energy to scoop me up in his arms and spin me around a few times.

Dad might have been tired from his day of work, but he still had enough energy to scoop me up in his arms and spin me around a few times.

In 2001, my parents opened a second store in Hearne, Texas. This location looks identical to their first store—also covered in red, white and blue paint—and has become their main shop. These days, that location is run by my dad and my two older brothers, while my grandmother—dad's mom—runs the original store.

On the weekends, I also tagged along with my dad to the tire shop and tried to hang around with my brothers as much as possible. Even though they had work to do, they always found some time here and there to play with me throughout the day. Raini was there as well. She was like the mother hen of the yard. Anytime my brothers and I did something she thought was dangerous, she'd tell us, "Don't do that! You're going to get hurt!" As soon as she left, we'd keep doing what we were doing anyway.

I have a vivid memory of one day being in the office of the shop when my dad taught me how to write my name.

Although I had my little phonics book in which I practiced writing letters, Dad brought out a yellow notepad and wrote my name. He then took the time to show me how to write each letter. I practiced it again and again. It was pretty sloppy in the beginning, but after a while, it started looking pretty good. Looking back, I probably could have put a little more effort into it. Honestly, I was more interested in spinning myself around in the cool swivel chairs!

There was a small television set on a table in the corner of the shop that I liked to sit in front of many mornings. I spent a lot of time watching *SpongeBob SquarePants* and *Bob the Builder*. Raini and I would also watch the green turtle show, *Franklin*. After setting my sausage, egg and cheese biscuit down on one chair, I'd pull up another chair next to it and eat my meal. It was the perfect morning routine.

My dad also had another location for his business that was a combination warehouse and tire shop. In the warehouse, there were rows of tires stacked high, and sometimes I would crawl up and climb them. The tire columns were like my personal jungle gym. One day, I climbed all the way to the top of one of the highest stacks. Getting up there was the easy part. Finding a way to get safely down was another story, but somehow I found the courage.

My time spent at the shop was always fun because my dad and I always horsed around with each other. Sometimes I would get onto the back tailgate of his truck and jump into his arms. Just to scare me sometimes, he'd take a step back while I was in midair before catching me. Talk about a leap of faith!

reel life lessons . . . so far

I was a curious kid and always following my dad or one of my brothers around the shop. It was like I was everyone's shadow because I was always going off in every direction.

Like a sponge, I soaked up everything that was going on in my surroundings. Even when I was just a little kid, I thought I could change a tire myself. There were tire mounting machines and big compressors. It was heavy-duty machinery.

"Go around the front of the car," Dad told me one afternoon. "I need you to help me pick this car up."

When I got up to the front, he told me to lift. I put everything I had into it, and wouldn't you know it? The car actually started rising up!

"Dad! I'm doing it!" I yelled.

"Yes, you are," he told me.

Truth be told, he was actually using the car's jack to lift. I was amazed I was strong enough to pick up an entire car by myself until I realized what he was doing. Still, Dad made me feel like I was a superhero.

Dad made me feel like I was a superhero.

The first five years of my life were primarily spent at the tire shops. My sister and I even learned how to count by helping my parents balance the cash drawer and making change for customers at the cash register. I used to see my older brothers' dirty hands after a day of changing tires and

wanted to get mine dirty too. When my dad let me, I would love to go outside with my brothers and roll tires around the back of the building. At the time, I thought it was fun, but now I realize my tire-rolling game was actually a way my brothers could get me to do their job while they took a rest. I didn't really mind but some of those tires were as big as me. I actually got run over by one because I thought I could jump it and missed. Yet another lesson learned from working at the tire shop—always be on your toes!

> Yet another lesson learned from working at the tire shop—always be on your toes!

Once I was old enough, I began sweeping the floors of the shop—at least I tried. I mostly just pushed the broom around, scattering the piles of dirt and debris. I was too young to understand that I was actually doing a chore. It wouldn't have mattered anyway because I liked helping. When I was done, my dad gave me a quarter, which I promptly deposited in his candy machine to get a pack of gum. I always shared it with my older brothers and sister.

Sometimes my parents would leave me with my grandmother at the shop she runs. I loved spending those days with her. I found an innovative way to build a set of steps using the drawers in her desk for climbing up and down so I could sit on top and hang out with her.

reel life lessons . . . so far

In the many years before being cast in the role of Manny, I saw the everyday side of life.

In the many years before being cast in the role of Manny, I saw the everyday side of life. Although I have been acting on and off since I was six years old, there were plenty of gaps in between acting jobs. I'd help my dad around the tire shop in any way I could, whether painting the office, building, sweeping the floors or selling tires. If my dad was out there sweating, it was always my honor and pleasure to stand right next to him and work up a sweat too. *Everyone* at the tire shop works hard.

Mom and Dad went to work having to wear different hats every day because they were dealing with all kinds of people at the store—a trait I picked up at an early age just by being around them. Some folks came in angry because they needed to spend money on new tires or had had a bad experience just before getting to the store while others were just as happy as could be, despite their circumstances. Still, others could get painfully uncomfortable because they couldn't afford to pay for the tires right then and there, even if they needed them right then and there. They'd promise my parents they would come back on Friday after they got paid—and you know what? They always did.

I don't think anyone planned it, but the family tire shop became the place of some of my biggest life lessons.

It definitely taught me one of my most valuable lessons in life: the Golden Rule, which says "Do unto others as you would have them do unto you."

I don't think anyone planned it, but the family tire shop became the place of some of my biggest life lessons. It definitely taught me one of my most valuable lessons in life: the Golden Rule, which says "Do unto others as you would have them do unto you."

I remember noticing at a very young age just how different people can be. I could spot the grumps from the happy-go-lucky customers before they walked through the door. Maybe it was in the way they walked across the parking lot or perhaps I could tell from the looks on their faces, but I somehow always knew who would be kind and who would be rough around the edges. Watching my parents interact with customers and then experi-

encing so many different types of personalities at such an early age has helped me learn to deal with all types of people. Let's face it, if someone comes into my parents' store and that customer is upset, it likely has nothing to do with any of us. It became a game to me—one in which I made it my mission to try to turn around the grumps. I'd crack jokes or do something silly to break their mood. Once I did, they would leave the shop feeling so much better than when they had come in. You might say the tire shop helped me sharpen my improvisation skills at a very early age. To be successful in sales, you have to be ready for everything and everyone. You need to stay on top of it all.

> Experiencing so many different types of personalities at such an early age has helped me learn to deal with all types of people.

My parents never had to tell me to be nice to others. They taught me through their own actions. I'm not the wheeler-dealer my dad is; but I knew how to be polite, and I could answer most of their questions—except when it came to price. That is always when my dad would step in and take over.

You might say the tire shop helped

me sharpen my improvisation skills

at a very early age. To be successful

in sales, you have to be ready for

everything and everyone. You need

to stay on top of it all.

I had a natural ease being on the sales floor that came with spending so much time at the shop. I would do the best I could, but sometimes, I'd have to defer to my dad. The benefit of growing up with that comfort is that now if I don't feel comfortable with something, I am not a jerk about it. I find a polite way to share how I am feeling with others, even if it means taking a risk.

I find a polite way to share how I

am feeling with others, even if it

means taking a risk.

We are a modest working-class family, something I am especially proud of and very grateful for. We didn't have a lot, but what we did have, my parents worked hard to achieve. As far back as I can remember, we never planned a family vacation because without fail whenever we tried, something always came up to prevent us

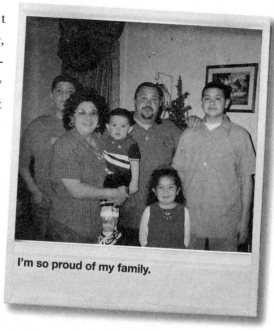

I'm so proud of my family.

from leaving the store. All of our family trips had to be taken whenever we could get away. When those windows of opportunity presented themselves, we all did what we would have to do to just get up and go. Outside of those rare occasions, my parents worked hard every single day so they could take care of their children and pay the bills. Whenever they shared their stories of their early years, they always say it was an exciting time.

We are a modest working-class family, something I am especially proud of and very grateful for. We

modest family

didn't have a lot, but what we did have, my parents worked hard to achieve.

I still enjoy going back and working at the tire shop. Although many customers recognize me from *Modern Family*, I do my best to fit in and be a part of the family business. People think that an actor's life is so glamorous. While there might be a lot of fun perks and it may be a different type of career than most people have, it is still work like any other job.

Whenever Julie Bowen (who plays Claire Dunphy) and I see each other on the set, we break out into a glamorous ballroom dance, as if to say an actor's life is nothing but a waltz!

"How was your weekend?" she'll ask.

"Great. How was yours?" I ask as I spin her around the stage.

It's funny every time we do it!

I don't think I could ever have achieved any level of success if it weren't for my days working with my family first.

reel life lessons ... so far

Both of my parents are very proud of what I have accomplished, but in retrospect, I don't think I could ever have achieved any level of success if it weren't for my days working with my family first. Everything I am, I owe to those experiences. Sure, people come into the store to get a glimpse of the kid from that TV show, but I am there to just be that kid from that amazing, hardworking family. I have seen my dad beaming as I pose for a photo or sign an autograph here and there. What I really hope is that he can see how happy I am to be a part of a business he has worked so hard to build.

Not long ago, I took my dad aside and told him that whenever he retired, I would buy the business from him and run it on my own. When my brothers heard about my offer, their response was "Take a number and get in line!"

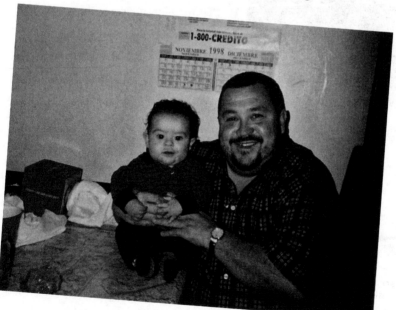

My dad is the best father a kid could ask for.

modest family

There is greater value in dignity than in all of the money in the world.

I've watched my dad work hard my entire life, and seeing him makes me want to work hard too. He taught me there is greater value in dignity than in all of the money in the world. And when you work for the things you have, there's a tremendous amount of pleasure in that achievement. My dad always taught me that when you put 110 percent into something, that is what you're going to get out of it. If you only put in 50 percent, that is also what you'll get out. I've never forgotten his advice and always strive to give my all.

I learn so much from my dad, even by simply watching him.

When you put 110 percent into something, that is what you're going to get out of it.

Dad continues to motivate me because no matter how challenging or hard things can sometimes get, I have never seen him give up. The way my family sees things is that hard work isn't going to kill you—it builds you up, gives you character and makes you stronger.

Although my dad is the best father and role model any boy could ask for, Ed O'Neill has become like a second father to me. Truthfully, I didn't know much about him when I landed the part of Manny on the show. Ed is not only a great guy, but also a total professional. Whenever I am having trouble with my lines or start mumbling my way through the dialogue in the script, Ed pulls me aside. He calls me "kid" on set. "Hey, kid, come here for a minute," Ed says. He then helps me figure out what I am doing wrong and make the right changes.

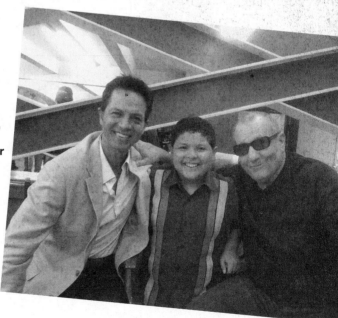

With Ed O'Neil, who plays my stepfather, and Benjamin Bratt, who plays my biological father on *Modern Family*.

There was one particular time at the end of the "Salsa" episode, in which my character Manny was teaching Jay to dance, when I couldn't get a specific line right. It seemed like a simple thing to do, but I was emphasizing the wrong word time after time. Different people on the set were giving me suggestions on how to deliver the line, but I just simply wasn't getting it. I had a mental block. Ed stepped in and told me exactly what to do. On the next take, I did as he said and totally nailed it. I probably should have asked him in the first place!

> Every performer looks to be validated, so it is nice to hear such a thing from an accomplished fellow actor.

I always listen carefully to what Ed has to say because he is a gifted actor. He knows what he is talking about and is kind enough to take the time to help me when I need it. Sometimes he even takes it a step further. From time to time, after we are finished shooting an episode, Ed e-mails and tells me I did a great job. It means a lot to have such a wonderful and talented actor give me praise and support. It lets me know that he appreciates what I am doing and acknowledges that all of my long hours of preparation are coming through in the work I am performing. Every per-

former wants to be validated, so it is nice to hear such a thing from an accomplished fellow actor. I can learn from each piece of advice Ed gives and take it along with me into future scenes. Someday I hope I'll be in a similar position to do the same for other up-and-coming actors.

Dear Journal,

I've learned so much from my dad. When I grow up, I want to be just like him.

there's
nothing
like a
big sister

i am the youngest of four kids. I have two older brothers who are, well, a lot older than I am—and my sister, Raini, who is five years older. You might say Raini is the bread on my grilled cheese sandwich. Actually, she's not just the bread, but also the pan, the butter, everything that goes into making grilled cheese. I'm just the cheese that makes that sandwich a little bit better.

People often ask why Raini and I spend so much time together. After all, she is five years older. The answer is simple: my sister has always had my back.

From the very moment I came into the world, Raini took care of me like a mother hen. Even then, she treated

me like I was her own living doll, pushing me in my stroller, giving me my bottles and doing mostly everything she saw my mom do.

For the first few years of my life, it was pretty much just Raini and me at the house because by the time I came along, my older brothers were already grown-up and out on their own. Although they are awesome big brothers, there was such a big gap in our ages that we never had the same kind of connection that I share with my sister. And now that Raini and I are living in Los Angeles, far away from our family in Texas, we're even closer. We're both pursuing acting careers, so we've shared many of the same experiences—from the anxiety of auditions to the excitement of landing a part.

> We're both pursuing acting careers, so we've shared many of the same experiences, from the anxiety of auditions to the excitement of landing a part.

For as long as I can remember, Raini and I have always gotten along really well. When we aren't with each other, it feels like I'm missing my partner in crime. We love going to the movies together. We can share popcorn; but

when it comes to my drink, well, that's a different story. I get my own ICEE, and those I never share!

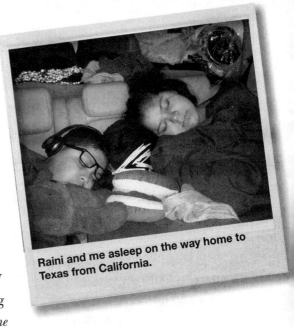

Raini and me asleep on the way home to Texas from California.

Along with enjoying quality time with my brothers, I also love to hang out with my sister. She and I like to have TV marathons watching *America's Funniest Home Videos*, which has inspired me to take a shot at making some of my own funniest home videos!

During my time on set, I like to wander around the different departments and soak up all the knowledge I can. Today, I know an incredible amount about sound, camera, grip work and lighting. I pay attention to everything. I know how to roll tape, zoom in and out on a camera and hold a boom microphone. I know my way around a sound board in the operating booth. I mic myself for sound each day. Who knows? Maybe there might be a future for me on the other side of the camera someday.

In my spare time, I have fun editing videos and making short films. I have a great appreciation for directors who have the ability to direct themselves because it is incredibly difficult. I don't think I could pull it off. When I write a script, I don't write it for myself. The reason behind this

63

is that it is hard to direct yourself. It is easier to have other actors play roles and advise them. I haven't asked to direct an episode of *Modern Family* yet, but hopefully, I'll be able to in the future. I would also like to eventually write an episode of *Modern Family*. In the meantime, I am going to sharpen my skills and continue to make home movies with my sister.

We recently produced a video for our newly formed Slap Happy Productions YouTube channel. Our company got its name from Raini every now and then giving me a playful slap. Our most recent release is a short called *A Nightmare on Elmo Street*, named after Raini's favorite movie franchise, *A Nightmare on Elm Street*. We filmed everything and edited it down to less than three minutes in a single day…in *three hours* actually, which is really fast for film-making!

Since Raini has grown up with three brothers, a few years ago for Christmas, Ray, Poppi, and I decided to chip in together and buy her something really special—an acoustic guitar she'd been hinting at wanting for quite some time. Being mischievous brothers, we couldn't just wrap it and give it to her. When we got home, we removed the guitar from its case and replaced it with a ukulele. I hid the guitar behind the couch so Raini wouldn't see it. When she opened up the big guitar case, the little ukulele was sitting inside. The look on her face was priceless.

"Really," she said, scowling at us. "Okay. Where is the guitar?"

"What guitar?" I asked. "We bought you this cool ukulele."

Although my brothers and I tried to hold out, we

couldn't for long. I went behind the couch and handed Raini her new acoustic guitar. She ended up loving our gift.

> Dear Journal,
>
> Raini and I have great movie nights. The last movie we watched was the latest *Transformers* movie. It was awesome. I love spending time with her and really appreciate that she usually lets me pick the movies! Maybe—no promises here, but just maybe, I'll let her pick the next one!

Raini and I like to make each other laugh by quoting funny parts of our favorite movies or singing the lyrics from our latest favorite songs. This practice has become a family habit, as my parents and older brothers often join in too. One of our favorites is Will Farrell's character in the movie *Elf*. Every time I am on an escalator, I stretch my legs out like he does in the movie, and it cracks us all up. My sister will laugh while warning me that I shouldn't do that trick because I could fall. Even now, she sometimes still acts like a mother hen! Still, whenever we are laughing together, especially when we are all together as a family, I know in my heart it's a good day. And thankfully, we laugh a lot, which means we have a lot of good days together!

When Raini is quiet in her room, I'll go in and make her laugh. You could say that making people laugh is my "thing." The secret to being a good brother is sharing the good times and being there through the tough days too. I am my sister's number one fan. We support each other in our careers and lives. No matter what happens, she can count on me forever.

Raini and I can tell each other anything, and the best part is knowing that it always stays just between us. We get along great and support each other in everything we do—especially in acting.

If it weren't for Raini, I'm not sure I would have gotten the part of Manny on *Modern Family*. I was still so new to the business when I auditioned for the show. I had been on other television shows and had done a bunch of commercials, but at the time, I hadn't done anything as big as *Modern Family*. Raini prepped me for my audition by helping me understand who the character was and by running my lines over and over with me until I thought I had really nailed it.

When I went to my first audition for the part of Manny, I was one of many kids trying out. The casting director thought I was good but told me they were looking for something different from what I had brought to the character. They said they wanted a little more Antonio Banderas and a little less Speedy Gonzales. I was being given another chance to show the producers I was their kid.

We practiced the lines over and over.

"Slow down" Raini would say.

"Pause there," she advised.

reel life lessons . . . so far

"Be happier..." And so on.

What I didn't know was that there would be another five auditions until I was finally asked to come in one last time to read for the network. That round is one of the final steps before booking the role. On the way home from that audition, my dad called to say I had gotten the part. At that time, the show was just a pilot—meaning, there was no guarantee it would be picked up as a series by the network. It's really a trial run to see how the show looks and whether audiences respond well to it. Still, it was a network television show in which I would be a series regular. I was in total shock. In fact, I was in the backseat of my mom's car and nearly hung myself with the seat belt strapped across my shoulder because we had just left the final callback when we got the call.

When we got home, I told my mom I wanted to play a joke on Raini, who was waiting for us to come back. I put fake tears in my eyes and pretended to be crying when I got out of the car.

"I didn't get the part," I said to Raini. Oh yeah. I'm an actor, so I really poured it on, if you know what I mean. "It didn't go well at all, Raini. They said I wasn't 'Manny' enough." Boohoo, I was crying like a baby.

"That's okay, Rico." Raini was trying to comfort me.

"And there's one more thing they said...." In between sniffles, I managed to spit out "I booked it!"

It took Raini a second to realize that I had just punk'd her. But when she did, she was so happy for me! That is, until she got mad at me for playing a joke on her.

there's nothing like a big sister

Dear Journal,

A few years after I was cast as Manny, I attended the *Shrek Forever After* premier, at which I had a chance to meet Antonio Banderas in person. This was a dream come true for me because he has always been one of my role models in acting. When we were introduced, I said, "Hi, my name is Rico Rodriguez and I am on a show called *Modern Family* and I based my character on you." When I said that, Antonio started laughing. To be honest, I wasn't sure if that was good or bad. I asked him if he would take a picture with me, which he did. Before I could explain why I based Manny on him, Antonio was called away because the film was about to start. But it was okay with me because at least I got to take a picture with him.

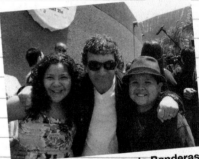

Raini and me with Antonio Banderas.

reel life lessons ... so far

The truth is, my sister worked with me every day and pushed me really hard to be ready, but in the end, it was worth it because I got the role of Manny. Raini played a big part in helping me get that part, which I am sure wouldn't have happened without her guidance and support. Now that's true sisterly love and devotion.

We are truly so happy for each other, and so appreciative of all the opportunities that come our way. In fact, as we have grown older, it has been the sharing of these times that make them so great.

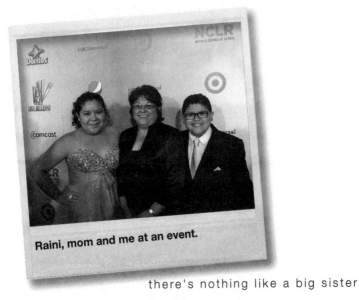

Raini, mom and me at an event.

there's nothing like a big sister

A lot of people ask me if my sister has ever been jealous of me.

Answer: Never.

We are truly so happy for each other and so appreciative of all the opportunities that come our way. In fact, as we have grown older, it has been the sharing of these times that make them so great. We really are blessed.

Dear Journal,

My sister has a TV show called *Austin and Ally,* which is on the Disney Channel. I know this has always been her dream, and I'm really proud of her! I can hardly believe the two of us have our own television shows. I really like her character, Trish. Does it make me a bad brother that I like Dez too?

reel life lessons . . . so far

being a
good son
can be
the most
rewarding
role of all

there's a lot of responsibility that comes with being a good son. The truth is, sometimes it's really a blessing, and at other times, it can be a bit of a struggle. I feel really lucky that I have two people in my life, both of whom not only want to take care of me as their child, but also take great pride in everything I do. That makes being a son really, really cool. But I also know that I have to listen to those people—like, all the time. I don't mind that part so much because I know my parents are *usually*—okay, make that *always*—right.

What kid doesn't love a red lollipop?

If someone isn't feeling right, I just want to make things better.

When I asked my mom honestly if I was a good son, she said that I was. She said that I am truly lovable (insert a collective *Awww...*), and that most of all, I want other people to be as happy as I am. If someone isn't feeling right, I just want to make things better. She said that is a very special way to be.

We are a family that is used to being together, so it was extremely challenging for everyone to be separated from our home and loved ones back in Texas—especially my dad. When we first moved to California, it was hard because it was all so new to us. When we lived in Texas, we were living in a house out in the country—no neighbors to speak of and no noise. Living in Los Angeles meant moving to a condominium, with people upstairs, downstairs and next door to us on both sides. There was so much loud traffic! Mom had to learn how to navigate around a new city. None of us was ready for any of that. It was tough to get used to, but what choice did we have except to pack it in and go home—something we weren't ready to do. We were committed to being in L.A. for one

reel life lessons ... so far

year, and in my family, when we commit, we give 100 percent of our effort.

Still, it wasn't easy.

Dear Journal,

On February 24, 2010, my sister-in-law and my brother Ray became the proud parents of a brand-new baby boy. The Rodriguez name continues. I love having another partner in crime and being an uncle who can show him the ropes on how to survive living with all these girls in our family!

I can tell when Mom wishes Dad were around to give her a hand at times, so I do my best to be the man of the house in his absence, but he has some really big shoes to fill!

I have two eyes and ears, so it's easy for me to see how hard it is on my parents to be apart. I am especially aware of how hard it has been on my mom to be away from my

being a good son

older brothers and her grandchildren since we left for Los Angeles. You can imagine how awesome it feels when we go back to Texas on our hiatus. Having all of us back together is so much fun. I can tell when Mom wishes Dad was around to give her a hand at times, so I do my best to be the man of the house in his absence, but he has some really big shoes to fill.

They taught each of us the importance of being polite, showing respect, staying down to earth, having a sense of humor and remaining heartfelt. These are the characteristics and traits that will stay in each of us, no matter what we decide to do for a living, the people we date or eventually marry and where we choose to live.

reel life lessons ... so far

My dad would like to be with my mom in Los Angeles to be a part of everything happening with Raini and me. But he cannot run his business from Los Angeles. I call my dad a lot, so he knows we are always thinking of him. I tell him about school and joke around by saying that I want to drop out. When he asks why I still go, I tell him I have no idea, and then we both just laugh.

Ray and me poppin' wheelies.

I'd like to think that I might be ultraspecial, but in my family, I'm not because my parents have raised all of their boys the exact same way. They taught each of us the importance of being polite, showing respect, staying down to earth, having a sense of humor and remaining heartfelt. These are the characteristics and traits that will stay in each of us, no matter what we decide to do for a living, the people we date or eventually marry and where we choose to live.

I was lucky enough to have two older brothers—Poppi and Ray, or Ray-Ray. They are both amazing sons I have looked up to as awesome role models along the way. They have shown me how important it is to treat our parents with love, kindness and respect. My brothers are thirteen and twelve years older than I am. Since there is such a big

gap in our ages, I didn't get to spend a lot of time with my brothers growing up. By the time I was five years old, they were both out of the house and living on their own.

My older brothers have shown me how important it is to treat our parents with love, kindness and respect.

Even though I didn't get to hang out with them much, I definitely had the chance to witness how they treated my mom and dad along the way. Although I live in Los Angeles and they're back home in Texas, they still influence me in ways they can't possibly imagine.

Poppi, which means "little daddy," and Ray both help my dad run the family tire business, which they now co-own with my father. Poppi and Ray each have three kids—five girls and one boy between them. Seeing my brothers provide for their families and be good husbands and fathers inspires me to want the same thing for myself when I grow up. The only difference between us is that I want to own a tire shop like they do, but I still want my mom and dad to live with me, so I plan to build a guesthouse someday so they will always be nearby.

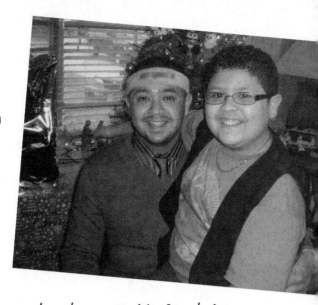

Here I am with my brother Roy Jr., the fashion guru, during Christmas.

Seeing my brothers provide for their families and be good husbands and fathers inspires me to want the same thing for myself when I grow up.

In 2010, we were asked to do a photo shoot for *People* magazine for a late December issue. It was a spread about how my family and I like to spend the Christmas holiday. I really wanted to have my older brothers involved in the story. After all, they are so much a part of me and who I have become as I continue to mature. My older brothers and father flew to Los Angeles so they could participate in the photo shoot and so we could all be together as a family, hanging out like old times.

being a good son

Since my mom, Raini and I live in a three-bedroom apartment in Los Angeles, my brothers and I hung out in my bedroom, watching football while the crew set up all of the lighting equipment for the shoot. I enjoy being with my brothers so much. There is nothing better than hanging out with the guys and watching football. Dad would come in and watch football from time to time too.

> There is nothing better than hanging out with the guys and watching football.

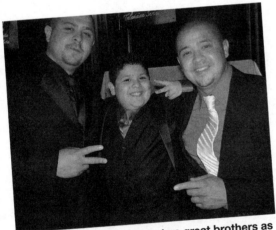

It's nice to know that I have two great brothers as role models to look up to.

My older brothers were really happy to have the chance to come to California to experience what Raini and I are doing and, of course, to be doted on by our mom. The only time it seems I get to see them is when we find the time to Skype with one another. While it's a great way to stay in touch, it isn't nearly the same as being together in person. It was really touching to see everyone gathered together—and so, so happy.

reel life lessons . . . so far

When I am looking for some advice from my older brothers, I don't purposely seek out either one of them. It comes down to which one answers the phone first when I call back home to Texas. Both of them are really bad about answering their phones, and my calls almost always go to voice mail. So, for the most part, whoever answers is the one I ask my questions.

I will say that if I have a particular fashion question, I do try to get ahold of my brother Poppi. He is the type of sharply dressed guy who matches his shoes with his shirt and wears Polo. He dresses well and knows how to put a nice outfit together. If I need to go shopping with someone, I know that Poppi always has me covered. He knows what I need for everyday clothing, for when I fly and for when I need to step up my game a little and dress up.

Poppi talked me through getting ready for *The Emmy Awards Show* last year. We started shopping about a week before the show. I had some ideas of what I wanted to wear but I wasn't completely sure. So, I called Poppi. He had a few ideas about what would look good on me. When he mentioned wearing a nice suit and tie with a matching handkerchief, I knew it was the way to go. I went with a teal green shirt, a black vest, a teal green bow tie, and a teal green pocket square. His ideas are usually right on.

It was extra special to share my room and time with my brothers and my dad. Ray and I are very much alike. We are both self-confessed Mama's boys and extremely sensitive; we would be happy to have her live with us forever. Whenever we're out and about and see a good-looking girl, Ray always says the same thing: "Rico, go get her

number for me." You have to love my brother. He jokes around about using me as a wingman, but it is mostly just playful banter between us because I have never actually gone up to any girls to get their number for him. Ray is a joker just like me, while Poppi would never do something like that, even to joke around for fear of not being a proper role model.

Being together felt like old times, especially with everyone picking on one another in good fun, laughing and reflecting on stories from our past. We didn't have a worry in the world except being together and what we were going to have for our next meal.

One night during that weekend, Dad, Ray, Poppi and I stayed up late just talking about cars—something my brothers and father are all very interested in. We even decided to go out the next day and buy a model car we

could build together. Being together felt like old times, especially with everyone picking on one another in good fun, laughing and reflecting on stories from our past. We didn't have a worry in the world except being together and what we were going to have for our next meal. That family weekend was very special—one I want to make sure I'll always remember.

And the Rodriguez name lives on....

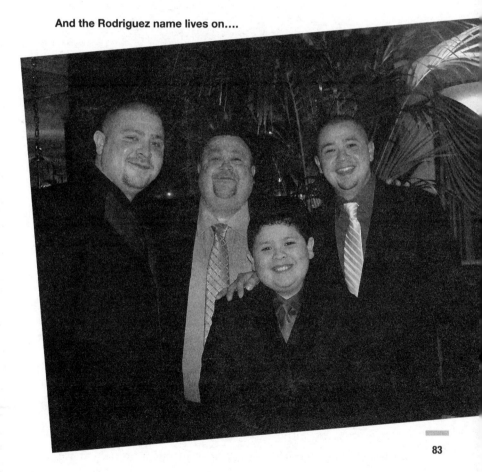

being a good son

Dear Journal,

My dad and I bought our REAL first car together. It's a 1949 Chevy Fastback deluxe! I'm really excited to work on it with him. I love doing guy things with my dad. I might not be old enough to drive it yet—but by the time we get it fixed up, I will be!

reel life lessons . . . so far

it's better
to *give*
than to
receive,
but *getting*
isn't bad
either!

holidays at home are always a big affair in our family, but the grandest of them all is Christmas back home in Texas. If it's true that everything is bigger in Texas, then our holiday gathering is no exception. Fifty family members flock to my grandma's (my dad's mom) house, where we all meet

Dear Journal,

There's nothing better than being back home in Texas for Christmas and being with my family. I don't get to see them often, and it's cool to do special things like swimming with my nieces and nephew and having some fun days with my big bros. Holidays are always fun, but Christmas is by far my very favorite.

My favorite holiday at Grandma's house.

for lunch at noon on Christmas day. When we are finished with our meal, we all gather around the tree to open our presents. Afterward, I enjoy spending some extra one-on-one time with my cousins playing video games or board games. There's nothing like bonding time with your family, especially during the holidays. Our celebrations are truly happy occasions. We have our share of the usual drama, but mostly, grandma's house is filled with an abundance of love, joy and laughter—and I mean lots of laughter.

If it's true that everything is bigger in Texas, then our holiday gathering is no exception.

What makes this particular holiday even more special to me is that Christmas is also my other grandmother's (my mom's mom) birthday. I guess you could say it is a two-for-one celebration day! Traditionally, we head to my other grandma's house around five o'clock for our second Christmas of the day.

reel life lessons ... so far

I have to admit—presents are one of my favorite things about Christmas. Thankfully, I don't have to buy all fifty family members a gift! Although, now that I think about it...if I did, that would mean I would get fifty gifts in return! Still, it's better to give than to receive.

We only buy gifts for our immediate family be-

The best gift of all is family, and I have a lot of them! Here I am with all of my cousins.

cause it isn't realistic to buy that many presents. So we put everyone's name in a hat at Thanksgiving and pick one for whom we get to buy a present. We set a twenty-dollar limit on how much we are allowed to spend, which keeps everything fair and even. Although I love getting presents, as I have gotten older, I really enjoy giving them more. There's nothing better than seeing the look on someone else's face as he or she opens a gift I put so much thought into.

For as long as I can remember, the only thing my dad ever asked for was a new pair of gloves because he always seemed to lose his pair from the previous year. Yup—gloves. That was his one Christmas wish. A few years ago, my sister and I decided to break with tradition and pool our resources to buy Dad something special he'd have forever. We talked it over and decided to buy him a watch that year for Christmas. Dad always wears a watch, so we thought it would be nice to get him a really special one. I know it was

it's better to *give* than to receive

extravagant, but we wanted to give him something he would wear and something that would make him think of us every time he looked at it. Besides, he really deserved something that special because he gave up so much to make sure Raini and I had everything we needed.

We went to the local mall near our apartment in Los Angeles and walked into the nicest watch store we could find. I wanted to be a shrewd businessman like my dad, so I immediately told the salesman I was looking for a good deal.

> I wanted to be a shrewd
>
> businessman like my dad, so I
>
> immediately told the salesman I was
>
> looking for a good deal.

"I want a good watch, and I want a good price," I said in a slightly deeper than usual pitch.

The salesman began showing us everything he had, explaining to us that we could customize the watch by picking out the bezel, face color and band and even add diamonds if we wanted. We chose a two-tone gold bezel with a gold metal band. It was gorgeous. When the salesman gave me the price, I did my best to stay cool.

"Don't you think you can do a little bit better than that?" I was doing my best to sound like I knew what I was doing.

reel life lessons . . . so far

We finally came to an agreement on price. I told him to put it in a box and wrap it up for us so we could keep our gift a secret from Dad until Christmas. I have to admit, it was a lot of fun picking out that watch with my sister. Raini and I were thrilled with our purchase because we knew Dad would be so happy.

My dad isn't typically the type of man who cries very easily, but when we gave him that watch, he got very teary. I don't think I have ever had a better feeling about Christmas than I did that very memorable day. Seeing my dad so happy filled my heart in ways that only giving to others can bring. I learned an especially meaningful lesson that day too. You don't have to give an expensive gift for it to have a lasting impact. It simply needs to come from your heart.

The most valuable part of giving is the intention.

For my mom, that can be something as simple as telling her I love her or giving her some quiet time. She works so hard taking care of Raini and me all on her own. There never seems to be enough time to give back to her, so I do my best to make sure to do the little things like making her breakfast in bed, taking the time to watch something on television together or making her coupons she can redeem to have me clean the kitchen, wash the dishes or anything else I can think of to make her life just a little bit easier. And believe me—Mom loves to cash in those coupons as often as she can!

When it comes to Mother's Day,

well, there's not a more important

holiday in our family.

When it comes to Mother's Day, well, there's not a more important holiday in our family. We usually like to make Mom special little gifts and cards—she loves homemade things. But she also loves thoughtful gifts—ones for which we really come up with an idea that we know will have a meaningful impact on her. One year, my sister, brothers and I got together and had a Mother's Day ring made especially for her. Three of the children were born in July, so our birthstone is the ruby. My oldest brother was born in January, so his birthstone is the garnet. We placed the four stones in a beautiful gold setting so she can think of her children every day. Needless to say, Mom loved the ring and wears it all the time.

It's a shame Christmas comes only once a year. On my last visit to Texas for the holidays, I had the chance to spend some rare alone time with both of my brothers. Ray, Poppi and I went to the video game section of Best Buy and played the free demo of Guitar Hero all afternoon. We were there for so long, we almost missed dinner. Now, that's a sure sign of good times!

One time on *Modern Family*, I got the chance to fly a remote-control helicopter with an iPad. In the episode, I eventually lost control of it, and it disappeared. Seeing

that I had so much fun with that one on set that day, the show gave me a remote-control helicopter for Christmas. I couldn't wait to show it to my brothers, so when I went back to Texas for the holidays, I brought the helicopter with me.

One afternoon, my brother Ray and I were driving around looking for something to do when an idea hit him.

"Let's go to the mall so I can get a helicopter," Ray said. "That way I can fly mine and you can fly yours."

We went to a kiosk at the mall where Ray bought one for himself. I tried to convince him to get a small model so that it would be easier for him to learn how to fly and maneuver, but he wasn't listening to anything I had to say. Of course, Ray bought the *biggest* helicopter they had in stock.

That day, we went to the park near his house and started flying our helicopters. I flew mine with my iPad. Unfortunately, Ray's went into the trees and got caught on a branch. Luckily, he was able to shake it down without breaking it, but his luck didn't improve from there. He then took the helicopter high up into the air, actually so high the radio signal faded. The helicopter just kept going up and up...and up. It was like it had a mind of its own. After hovering for a few moments, it fell down into the middle of the street with a loud cracking sound. What we both discovered that day was the bigger the helicopter, the bigger the crack when it hits the pavement!

There's a saying I've heard that goes, "The bigger they are, the harder they fall." I didn't really understand what that meant until Ray and I spent the day flying helicopters

it's better to *give* than to receive

together. That afternoon, I realized that in general some-times life can go by pretty fast. I was so happy to spend some quality time with my brother, doing something so fun and yet so simple. This was a reminder that even though I live a pretty cool life working as an actor living in L.A., it's important to take time and enjoy being a kid—you don't want to grow up too fast because you'll surely miss having all the fun!

It's important to take time and enjoy being a kid—you don't want to grow up too fast because you'll surely miss having all the fun!

As I get older, I have a greater appreciation for the true meaning and spirit of the holidays. Although I love get-ting new toys and gadgets as much as the next kid, what I really love now is having my family all gathered together— a rarity these days, but the very best gift of all.

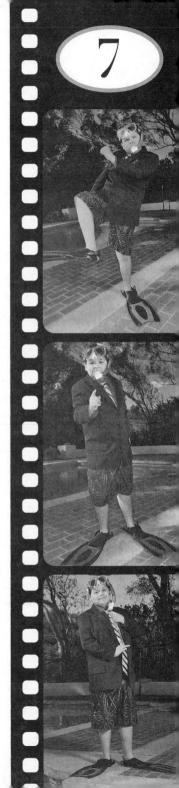

you're
never too
young to
be a family
man

by now, you know I've had the honor and privilege to grow up in a very tight-knit family. My parents have shown me the importance of sticking together as a unit and supporting one another in everything we do. It wouldn't make a difference to them if I decided to leave acting and pursue a completely different career as long as I was committed to working hard and making an honest living. I know, without a doubt, that my family will be right by my side supporting me in every way in any venture. It's so

important for a kid to grow up knowing he is loved and cared for no matter what he decides to do with his life. Everything I do and am as a person goes back to how I am being raised.

It wouldn't make a difference to my parents if I decided to leave acting and pursue a completely different career as long as I was committed to working hard and making an honest living.

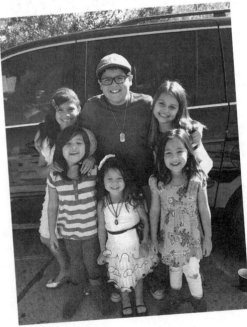

With my nieces, Myra, Alesia, Olivia, Zoe and Reagan.

reel life lessons . . . so far

I have many titles that describe me as a person, including son, brother, actor, magician, and entertainer, but the one title I wear with the utmost pride is that of Uncle Rico. Whenever I am back home in Texas, I like to spend as much time with my extended family as I can, especially my five nieces and one nephew, ranging in age from ten to just over a year old. Being an uncle carries a lot of responsibility because I have to be a good role model.

Dear Journal,

My twin nieces, Olivia and Zoe, are talking more and more. When they try to pronounce my name, they say *Keico* instead of *Rico*. It's really cute. I really love being an uncle.

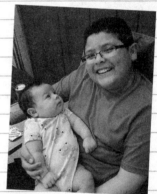

Holding my nephew baby Ray Jr.

Since I am only a few years older than my eldest nieces, I am more of a cousin to them than an uncle. They refer to me by my first name, yet they call Raini, who is older, *aunt*. I hope they will someday come around to calling me Uncle Rico, because that's who I am. I go out of my way to make sure that they do well in school. To track their progress, I have them show me their report cards. Whenever they get straight A's, I reward them for their hard work.

you're never too young to be a family man

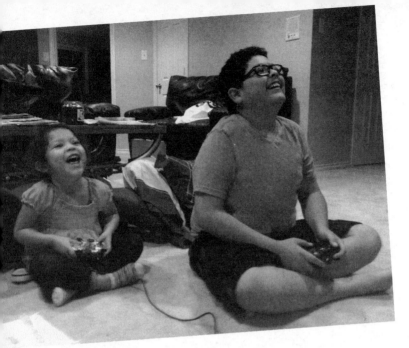

Teaching my niece Reagan how to play a video game.

When my niece Myra recently placed high in the state of Texas on a reading test, I gave her ten dollars and treated her to dinner. Whenever their report cards come, they call me because they know if they've done well, I'll make it worth their effort.

"Remember when you said that if I got all A's on my report card you would give me five dollars? Well, I got all A's," they tell me. "When can you give me the five dollars?"

I don't mind at all because caring about their education is the right thing for a good uncle to do!

Since moving to Los Angeles, I haven't had many opportunities to be with my nieces and nephew, so when I am home, I always make time to spend with them and will even volunteer to babysit, push them in their strollers and

play together. I make it a priority to be with them as much as possible because I really want the kids to know me. I think it's a little confusing for the younger kids when they see me on TV because they don't get that I am both an actor and their uncle. In fact, one of my nieces actually told me to get out of her TV, which, of course, made me laugh. I am grateful that they can see me on TV so they don't forget me while I'm in L.A.

To me, an uncle's role is to spoil his nieces and nephew and to be available when they feel like they can't go to their mom or dad for something. I mostly go to my grandma when I need someone to talk to. If something is bothering me, I always feel better after talking with her. She is one of my biggest supporters even though she still sees me as a little baby grandson—her "little movie star." Thankfully, she always gives me sound advice, usually reminding me that things happen in life. Grandma always gives me the reassurance that everything has a way of working out and that things will be okay. Best of all, Grandma always makes me feel better because she usually takes my side, even though I know I'm not always right. I guess that's what grandmas do!

Helping my nephew Ray Jr. walk around our house.

you're never too young to be a family man

If something is bothering me, I always feel better after talking to my grandma.

I also have a good relationship with my uncle David—who is married to my dad's sister, Janie. Uncle David reminds me of the character Phil from *Modern Family*, because he is the "try to be cool" dad type. He is really fun to be with and has taught me what being a good uncle is all about. He and Aunt Janie have a son named Chris, whom I really like to hang out with too. He is my older (by three years) and wiser cousin who loves to play video games more than I do. We spend as much time talking about football as we do playing games. I don't get the chance to play football very often, but I enjoy tossing the ball around and think it might be fun to someday play on a team. I would be a good running back because I can run surprisingly fast.

Chris and Raini are the two oldest teenagers in our family, so I will frequently call them "Mom and Dad" because they're both very nurturing. Chris is like a fun dad and lets me do pretty much anything, while Raini is like a mom, always telling us what to do, such as reminding us to clean up when we are done playing.

reel life lessons . . . so far

There's a great responsibility that comes with being a good role model. It's important to remember that as much as you look up to others, there are always others who will look up to you.

Sometimes interviewers ask me what I would say to other kids out there that are interested in doing what I am doing. I have a few things I always mention, things that my mom and dad have taught me over the years: First, *never take no for an answer because you are going to get more noes than yeses.* Second, *reach for the stars.* And last and maybe most important, *don't stop.* My family and I never back down and are fortunate to be where we are today. If you lose faith in what you are trying to do and quit, it is certain that you will miss out on every opportunity. Nothing is going to happen for quitters. It all goes back to something my dad taught all of us while we were growing up: whatever you put into something is what you are going to get out. It applies to everything, no matter what type of work you do. If you make a 100 percent effort, you are going to get the same 100 percent back. Anything less than the maximum effort and you shouldn't expect much.

you're never too young to be a family man

When I am not hanging out with my nieces or nephew, I will frequently tag along with my dad as he makes his weekly visit to see his mother.

My family and I never back down and are fortunate to be where we are today. If you lose faith in what you are trying to do and quit, it is certain that you will miss out on every opportunity.

Like clockwork, Dad will say, "We're not staying long, so no one take off your shoes."

Somewhere around nine or ten that same night—five or six hours later—everyone is still there, laughing and having a good time, just all of us being together. I have always enjoyed sitting in and listening to the adults talk about stuff. When I was younger, it was harder to follow the conversations because they seemed to jump from topic to topic so fast. Sometimes it's still hard for me to keep track of what subject they're all on, especially if I leave the room for a minute or two. By the time I walk back, forget it! I am completely lost! And I can't even jump in to ask what they're talking about because it is nearly

impossible to understand what they are saying. Come to think of it, maybe that's their plan. One thing I learned at a really early age was that my parents and grandparents have lived a lot of life experiences that I can learn from. They've met challenges and overcome dilemmas that I have yet to encounter. Don't underestimate the wisdom of experience. And it's that type of knowledge I gain when I sit around the kitchen table hearing my family go back and forth on everyday life.

> Don't underestimate the wisdom of experience. This is the type of knowledge I gain when I sit around the kitchen table hearing my family go back and forth on everyday life.

What I know for sure is that my parents and grandparents each guide me through their wisdom and hard-learned life lessons to be the best version of myself I can be so I will be well prepared to handle whatever life brings my way when the time comes. A lot of people tell me I am wise beyond my years. I don't know if that is true or not, but if it is, it comes from taking the time to really listen to

what my family has to say and understanding they are smarter and more experienced than I am.

A lot of people tell me I am wise beyond my years. I don't know if that is true or not, but if it is, it comes from taking the time to really listen to what my family has to say and understanding they are smarter and more experienced than I am.

if ya do
the crime,
ya gotta
do the
time

my parents have what most people might consider an old-fashioned relationship. In our home, my dad is the man of the house, the breadwinner and the head of our family. Whereas my mom is a modern-day homemaker who takes care of the kids, cooks, cleans, does the laundry and keeps the house running like a well-oiled machine. Dad is the disciplinarian, and Mom is the nurturer.

I don't get punished often, but when I do, Dad is usually the one who gives me my punishment while Mom is the one who explains what I did wrong in the first place.

Usually it's for something such as talking back or not doing my chores. I've been known to be a something of a know-it-all. I like to correct people, especially when they're telling a story wrong. I know it's not a great habit, so I am trying to break it, but I still sometimes slip up. Hey, I'm only human!

There have been plenty of times I've have been sent to my room to think about what I have done wrong. My parents have taken away my TV, video games and even my cell phone at times. By the time I come back to them and apologize for what I have done wrong, they want to make sure I have learned from my mistake before giving me back my privileges—and that's what those things are—a privilege.

I think it is good that my parents divide the power between them because there should always be a good cop and a bad cop to keep us kids on our toes.

Even though I don't like being sent to my room or having my privileges taken away, I think it is good that my parents divide the power between them because there should always be a good cop and a bad cop to keep us kids

on our toes. They may not think that I know what's what, but I do! And that's cool with me because I actually want my parents to give me boundaries, rules and guidelines.

I actually want my parents to give

me boundaries, rules and guidelines.

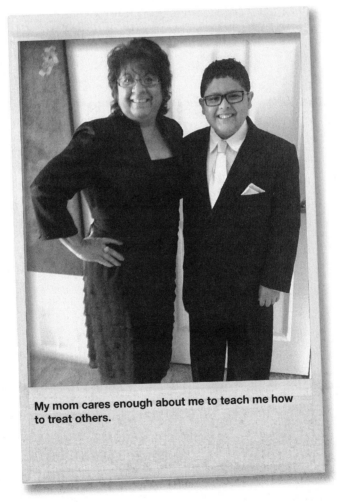

My mom cares enough about me to teach me how to treat others.

if ya do the crime ya gotta do the time

My family has always been the kind that talks about everything openly and honestly. We aren't the kind of family that keeps secrets unless it is meant to be a deliberate surprise for one of us. That's the only time you really can't break the Rodriguez family circle of trust. I had the gift of growing up in a family that allowed me to feel safe to talk about whatever was on my mind. I can tell them anything without worrying that I am being judged or without having to filter what's on my mind.

> I had the gift of growing up in a family that allowed me to feel safe to talk about whatever was on my mind.

By the same token, my parents expect me to be responsible with the privileges that they give me. Okay, I have to admit that I am not terribly responsible when it comes to keeping track of my cell phone. I typically have my phone on silent and misplace it a lot because, well, when I call it, it's on silent! Truth be told, I have gone through a lot of phones over the years. One phone even had a razor app that vibrated just like an electric razor that I used to pretend shave. I loved that phone. When I lost the last two phones, my parents got so fed up, they told me there would be no more phones because I wasn't responsible

enough to not lose them. I know it sounds bad and, yes, even a little irresponsible, but I am not losing them on purpose. The funny thing is, my phones always have a strange way of turning up sooner or later, whether I find them hidden in the armrest of our car or behind the computer in my parents' room.

I understand my parents really do know what is best for me and, therefore, they lay down the law based on that and are not mean or strict without reason.

I sometimes get jealous of other kids who are able to go out with their friends all the time because I have friends who invite me to hang out or go see a movie and such, but my dad isn't too keen on letting me go because it usually means staying out too late. For as long as I can remember, my dad has always said, "Nothing good ever happens after midnight." I'm not sure I really understand that theory now, but I am guessing I someday will! While I wouldn't dream of staying out that late—at least not yet—I understand my parents really do know what is best for me and, therefore, they lay down the law based on that and are not mean or strict without reason. I respect

if ya do the crime ya gotta do the time

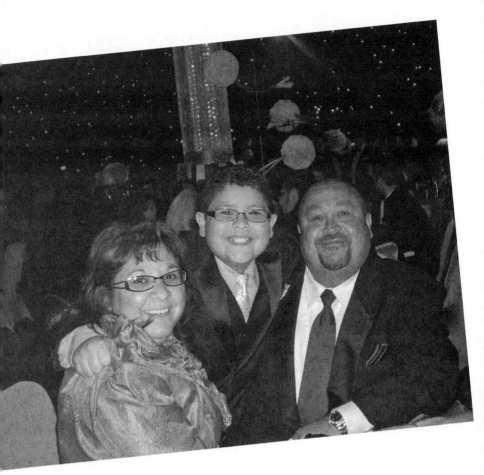

With both my mom and dad.

their wishes because I appreciate that they only want to do right by me. They know how important it is for me to get a good night's sleep, especially when I have to work the next day. I don't know how many kids my age are working and doing chores around the house but I guess if they are, these restrictions are really for our own good.

reel life lessons ... so far

Even when I give my mom or dad a little push back, they are strong in their will and know how to stick to their guns. They have no problem letting me know that they are in charge. Best of all, my mom and dad never let me forget that they are the parents. Although we have a good relationship, which is more often a friendship, they are still my parents. They've taught me that discipline is a good thing. It's actually a gift to your kids. It keeps them grounded and honest and helps them ready for the real world. I am extremely appreciative of my parents and the love they give me—even when I get disciplined.

> They've taught me that discipline is a good thing. It's actually a gift to your kids. It keeps them grounded and honest and helps them ready for the real world.

Dear Journal,

Here's a little secret about me that no one really knows: I cannot handle guilt. If I do something wrong, I cannot live with myself until I come clean. My parents know right away when something is up because I act

if ya do the crime ya gotta do the time

really guilty. When I finally confess to the truth, I always feel better, even if my mom lectures me. It's kind of funny though. You'd think that being an actor would give me the skills to act...well, less guilty. But it hasn't. I guess the subconscious mind is stronger than any acting method I've learned so far!

a penny
saved can
add up to
a whole
jarful!

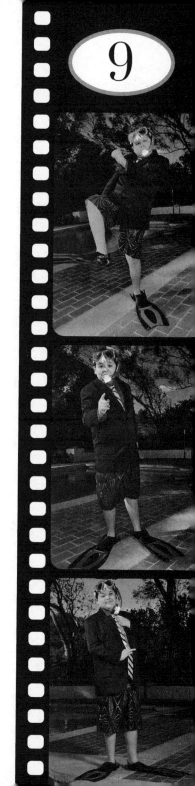

i grew up always hearing the sound of loose change jingling in my dad's pants pockets. This was a sound I loved because my dad usually gave me whatever coins he had with him. For a long time, a single handful of his spare change was considered my allowance. Lucky for me, my dad has big hands, so there was always a fair amount of money there. I never spent it—I saved it up until there was enough change to fill a large jar. Once I did that, I'd take my change to the bank and cash it in. One time I was

shocked when it turned out that I had saved fifty dollars' worth of loose coins! Those pennies sure do add up!

A few years ago, my sister decided it was time to negotiate a real allowance with our dad. We were both earning paychecks for the various acting jobs we were doing, so it made sense we should be allowed to reap some financial benefit from our hard work. Raini thought long and hard before calling Dad back home in Texas to share her well thought-out argument and what amount she thought was fair. I was too young to negotiate for myself, so I asked my sister to handle my interests too.

Raini spoke with our father and methodically laid out why she thought we deserved a real allowance. She gave him several reasons that sounded completely valid.

She said, "We both work. We make our own money. I am not asking you to give us your money. I am suggesting you take it from our paychecks."

"How much do you think is fair?" our dad asked.

But before Raini could respond, he said to her, "Why don't you think about your answer and call me back when you've come up with a number?" He thought this approach might deter her from being too aggressive or outrageous with her request.

One minute later, Raini phoned our dad back and said, "Tell me if this is going to be too much because we can always compromise. I was thinking forty dollars per paycheck is fair."

Without missing a beat, Dad quickly agreed. Frankly, I think he was expecting her to ask for a lot more than that,

so he closed the deal when he could before she suddenly changed her mind.

"And there's one more thing, Dad." Raini said. "I want Rico to get twenty dollars a paycheck."

This is one of the reasons I love my sister as much as I do. Even though Raini is five years older than me, she always thinks about my interests right along with her own. At the time, I thought she was getting the same amount as I was, so I was very happy when she told me that Dad agreed to the twenty bucks a week. I had no idea she was actually getting twice as much. He had one condition though: I had to continue doing chores around the house, such as taking out the trash, helping my sister clean and occasionally cooking for the family. When I found out Raini was actually getting more money than I was, I flinched for, like, a second, and then I realized she is a lot older and needs more money, so after I gave it some thought, it seemed fair. Besides, I still gather up all of the loose change I can find around the house and cash it in whenever I get the chance.

The art of negotiation is to always know your leverage and limits.

I grew up understanding the value of a dollar and earning my own money. I never want to be one of those kids whose parents give them everything they ask for.

a penny saved can add up to a whole jarful!

I grew up understanding the value of a dollar and earning my own money.

To me, things have so much more meaning and significance when you've earned them all on your own. For example, I love to build things with LEGOs, so whenever I have a few extra dollars, I will buy LEGOs so I can build some really cool stuff. I once built the *Millennium Falcon* from *Star Wars* out of 1,524 pieces in about a day and a half!

To me, things have so much more meaning and significance when you've earned them all on your own.

I am the world's biggest *Star Wars* fan. I love all things *Star Wars*. There's a store back in Texas that sells music, books and movies and keeps a permanent display up of cool stuff from *Star Wars*. One day, I walked in and spotted a real light saber made of glass. It lit up and made all of the sounds like the one Luke Skywalker uses in the mov-

ies. I held it in my hands as if I was about to go into battle. I had to have it.

"How much is this?" I asked the store clerk.

"One hundred nineteen dollars," he said, instantly killing my dream with the huge price tag.

Still, my wheels were spinning. If I saved my allowance for six weeks, I would be able to save enough money to come back and buy it. Better yet, if I worked at my dad's tire shop for a few days, I thought I could earn that amount even faster.

"Dad, I need to come into the store for four days and work." I announced.

"Why four days?" My dad asked.

"So I can make enough money to buy this light saber!"

Dad let me come to work so I could earn the money I needed.

"Dad, today I am not a kid actor—I am just a regular worker trying to make ends meet." I said.

You see, in my mind, I know I have to work for the things I want.

You see, in my mind, I know I have to work for the things I want. Thankfully, it all worked out. Dad spent those few days trying to teach me how to put a tire back on a rim, how to patch a tire and all of the other steps of working at a tire shop. As hard as I tried, things weren't going so well because my dad is an expert in his field, and,

a penny saved can add up to a whole jarful!

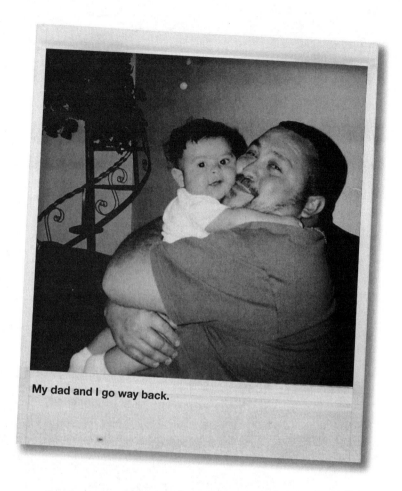

My dad and I go way back.

well...I am not. So it wasn't easy for my dad over those few days but it was worth it because I got to spend some quality time with him, working in the family business. I don't get that chance very often anymore, so I embraced every moment and appreciated the opportunity. Plus, I got paid for my time, and as soon as I had enough money saved, that light saber was going to be mine.

We all work hard at the tire shop but still take time out to have fun.

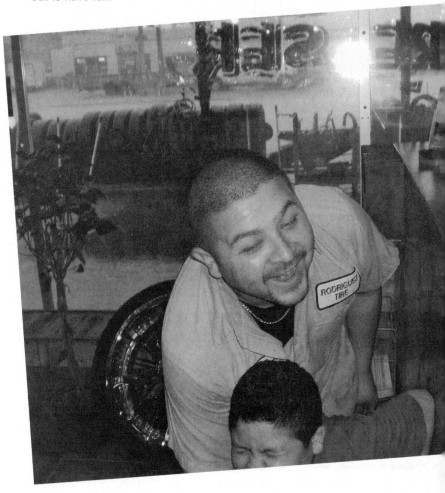

a penny saved can add up to a whole jarful!

Dear Journal,

One of my favorite episodes of *Modern Family* came during season one when Manny gets involved in fencing. At the time, I had never so much as held a sword, let alone fenced. The closest I had come was pretending to play *Star Wars*, using a broomstick for my light saber. The producers had an instructor come to the set and teach me the finer points of fencing for several weeks leading up to that episode. It was a lot harder than I expected it to be. I used muscles in my arms, back and legs I didn't even know were there. The sword itself isn't heavy, but you have to keep the tip up, which means you are engaging your shoulders and arms for extended periods. You cannot let your guard down for a second, or you will lose the duel. I was fascinated to learn that in medieval times, when opponents challenged one another to a duel, it was to the death.

I eventually did get my light saber and was more prepared to use it after training with the fencing expert than I would have otherwise been. Recently, Nolan Gould—who plays Luke on the show— challenged me to a duel for fun. When I struck my pose, he stopped, looked at me and said, "That's right. You have been trained. Forget it!"

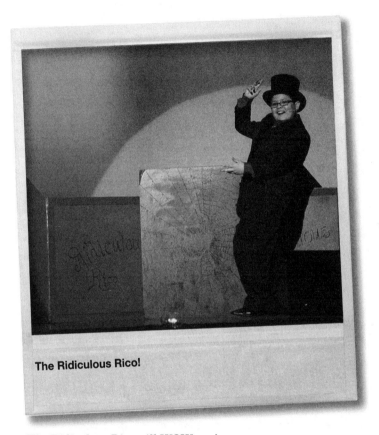

The Ridiculous Rico!

The Ridiculous Rico will WOW you!

The Ridiculous Rico will astound you.

The Ridiculous Rico will blow your mind and leave you asking, "How did he do that?"

Now, you might be asking yourself, "Who is *this* Ridiculous Rico?"

Ahem…Well, he would be me!

That's right. When I'm not acting, I turn into boy magician extraordinaire…*The Ridiculous Rico!*

Ever since I was a young boy, I've had a fascination with magic—especially close-up magic, such as sleight of hand and card tricks. A few years ago, my family and I were on a trip to Las Vegas. We stayed at the Palazzo Hotel. There is a magic store in the shops that connect the Palazzo to the Venetian Hotel. My dad was a little leery about me doing magic at first because he doesn't like anything that invites darkness or represents evil into our lives. But once he saw there was another side of magic that was entertaining, he came around and said I could give it a try. Besides, he knows I am a very persuasive boy with a passion and interest in something, which means I wouldn't let up on him until he finally said I could give it a go.

So Dad took me to the magic store, where I picked up a small magic kit that had an instructional DVD with several simple vanishing and reappearing tricks I could easily learn. I am a really quick study of things, so I picked up the sleight of hand stuff with great ease. I also learned a couple of cool card tricks and a rope trick and even how to make a coin push through glass. The first that I perfected was moving tiny red rubber balls under cones and then making them disappear. The trick is to ask someone to follow the balls. I always trip people up with that.

The real magic in magic isn't in the tricks—it's in the reaction you get from your audience.

I really enjoy practicing the art of magic, especially as I realize that people are amazed by my ability. You see, the real magic in magic isn't in the tricks—it's in the reaction you get from your audience. At least, it is for me. Hey, I was born to entertain! And believe me, this kid ain't no one-trick pony!

The more I perform for family and friends, the more I want to learn new and even more amazing illusions. Whenever I finish one of my demonstrations, I look at my audience and confidently say, "You've just been amazed!"

This has become my catchphrase whenever I perform one of my incredible awe-inspiring magic tricks as *The Ridiculous Rico.*

The first time I performed a magic trick on television was during an appearance on *The Tonight Show with Jay Leno.* This was my official professional debut as *The Ridiculous Rico*—boy magician. I was in my dressing room, nervous I didn't have a stage name as a magician yet. I was trying to come up with something that worked with Rico. I was pacing the room when my sister said, "You're being ridiculous! Sit down!"

"That's it!" I said.

I could be *The Ridiculous Rico!* And so that's how Jay

Leno introduced me that night, and it has stuck ever since.

Jeff Bridges was sitting next to me on one side while Jay was behind his desk on the other. I gave them each an Oreo cookie and then took one for myself. I told them the name of the trick was "You do as I do." Which basically meant I wanted them to do exactly what I did every step of the way.

First, I took a bite of my cookie and asked the guys to do the same with theirs. The thing is—I love Oreo cookies so much, I wanted my bite to reappear and make my cookie whole again so I could have more.

Impossible?

Not for *The Ridiculous Rico*!

So, I took another bite and then blew on my cookie, and lo and behold, it came back as a full Oreo. Jay and Jeff were shocked because they didn't see how I did it.

"That was not only fascinating, but delicious as well," Jay said, getting a good laugh from the audience.

Oh yeah. "You've Just Been Amazed!" I said...and I believe they were.

Ever since I was a little boy, ghosts and paranormal events have always fascinated me. One time, I was playing a really fun game called Loteria, also known as Mexican bingo. It is just like the traditional game of bingo but instead of numbers on Ping-Pong balls, it is played by using images on a deck of cards. There is an assigned number and name to each image. For instance, there are the weeping woman and the star unaware of the salaries paid. Dur-

ing the last game of the day, I needed the weeping woman to complete my card. Everyone had put in five dollars each, so the pot had gotten up to fifty-five dollars. I wanted to win more than anything. Wouldn't you know, I ended up getting the weeping woman card!

A few days later, I found out I booked a role on an episode of the *Haunting Hour* called "The Weeping Woman"! It sent shivers up and down my spine.

Because of my love of magic and ghosts, one of my favorite places in Hollywood is the Magic Castle. Built way back in 1908, it regularly showcases some of the most amazing magicians from all over the world including Harry Blackstone Jr., Doug Henning, Criss Angel, David Blaine and David Copperfield! Harry Houdini is even said to have performed there. My trip turned out to be an amazing experience. There are no visible doorways when you first enter the main showroom. We had to say a secret phrase to an owl mounted up on the wall, and then a bookcase slid open. The workers explained that there is one particular ghost named Irma who is always there. Apparently, she was a performer in her former life and likes to do the same now that she is a ghost. Irma plays piano. If you're nice to her, she will play your requests. She tends to appear sometime between five thirty and six thirty most evenings and hangs around until midnight or a bit after. Irma is also capable of carrying on conversations by playing musical answers to questions. You can request any song, and she will start playing it on the piano.

"Irma," I said, "surprise me with something."

Just then, Irma started playing the theme song of *Modern Family* on her piano!

It was crazy!

I'm not sure where she learned it because they sure don't carry it on iTunes.

Then I asked her to play "Hotel California" by the Eagles, and she started playing it. She knew almost any song. If she agrees with your selection, she will play a pleasant-sounding little tune, and if she doesn't like what you request, she will slam down the keys on the piano and make a freaky sound.

They also had private séances, but I didn't want to do anything like that because I was too scared. I just stuck with listening to the stories they told me about the history of the Magic Castle.

You can imagine how thrilled and stunned I was when I received a call to perform one of my tricks for the annual Academy of Magical Arts Awards. Although the award show didn't take place at the Magic Castle, but rather a larger venue to accommodate the crowd, it was still a great honor to be asked to perform in front of the best magicians on the planet.

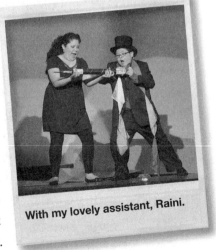

With my lovely assistant, Raini.

My demonstration was billed as one of the main events, which only added more pressure to the situation.

I planned several tricks that required me to use my trusty assistant—my sister, Raini. I performed several very fun tricks using scarves and other illusions. I was nervous to be up on that stage performing in front of so many professional magicians. I believe the audience enjoyed our performance. I got the thrill of a lifetime when I got to meet Lance Burton after the show. Mr. Burton was getting an award that night, and he came backstage to congratulate me for a job well-done. It was such an honor to meet him and a real compliment to hear that he thought I did a good job. There's nothing better than gaining the respect of your peers in business, especially when it comes from someone I admire.

> There's nothing better than gaining the respect of your peers in business, especially when it comes from someone I admire.

Although I really enjoy magic, I don't necessarily see my own show in Las Vegas in the future. You never know, though. In the meantime, it doesn't hurt to have a few tricks up my sleeve to entertain friends and family and even a pretty girl from time to time. There's not a better

icebreaker than pulling a quarter out of a girl's ear or making a card disappear and then reappear. I can even make a credit card go away with a magic wallet.

Performing magic and card tricks for my nieces is the best because of their wild reactions. They think anything I do is absolutely amazing, so they are the ideal crowd for any performer.

Even the simplest trick will entertain them.

One time, we were at a place called Atami's, and I had a clear cup and salt and pepper shakers. I put the pepper away and said, "I am going to make this salt shaker disappear." It's not much of a trick really because all I did was put my napkin in front of the pepper shaker and placed the cup in the middle where they couldn't see it. An adult would have known exactly what I had done, but to my nieces, this was *magic!*

Performing magic and doing *Modern Family* have both really helped me conquer my shyness. I am grateful for the gift of both and hope to someday get my chance to perform live at the Magic Castle.

embrace
your own
chef rico
and other
talents

like all boys, I really love my mom's cooking. I especially enjoy her spaghetti and meatballs, lasagna and pepper steak. When we first moved to Los Angeles, I had a hard time embracing "California Cuisine." To me, it all tastes the same and looks like Play-doh. I didn't get it, and I didn't like it.

"That's not food!" I'd say to my mom, pointing to a plate of lettuce and avocado that was supposed to be a meal.

A meal?

For who?

Squirrels?

I was only five at the time and spent most of my life eating Texas style, so I didn't know that people actually ate

only a salad as a main meal. When it comes time for holidays and breaks from shooting *Modern Family,* I can hardly wait to get back home and eat some Texas-style food, especially barbecue. In California, barbecue means a lean chicken breast with a thin layer of sauce on top. That is NOT barbecue—at least, not Texas style! When I think of good ol' fashioned barbecue, I am looking for some finger-licking, chin-dripping barbecue sauce with a side of Spanish rice and ranch-style beans!

Dear Journal,

My family makes some pretty delicious meals! I can't get enough of my mom's spaghetti, and I always get excited about my dad's barbecues. Their cooking truly tastes and feels like home.

P.S. Just a thought: remember to tell Susan to get my family a cooking show!

My dad loves to experiment with different styles of barbecue, so when I get a chance to be home with him, we'll come up with different recipes to try on slabs of ribs and write the best ones down like we are on a cooking show. One of my favorites involves pouring beer into the sauce and letting the ribs marinate and then cook in it. I can't taste the beer on the ribs, and I am told the alcohol cooks

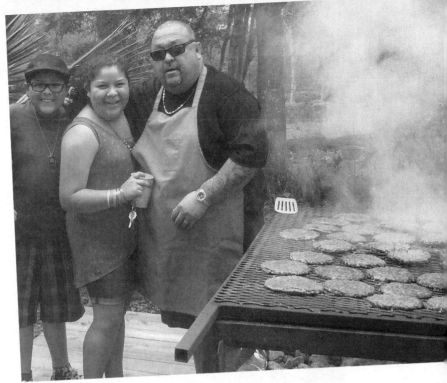

My dad's famous BBQs.

off in the high heat of the grill. It's one of my new favorites. Another is soaked in Worcestershire sauce, and a third favorite is made with apple juice as its marinade. Oh yeah, now you're talking my language.

My dad uses an oak-wood-burning iron pit to do his grilling. The actual barbecue weighs around 1,200 pounds! It's the real deal. Together as a family, we sure have logged a lot of miles on that thing. When my dad cooks, he cooks enough to feed an army because that's what our family is! Whenever it's someone's birthday in the family, they request my dad's barbecue weeks in ad-

141

embrace your own chef rico and other talents

vance! Even my nieces get excited about his world-famous sweet chicken wings. Dad is the only person on the planet who knows the secret rub recipe he uses, but I hope that someday he will pass it down to me. The only ingredient he has shared with me so far is lots of brown sugar—everything else is his secret!

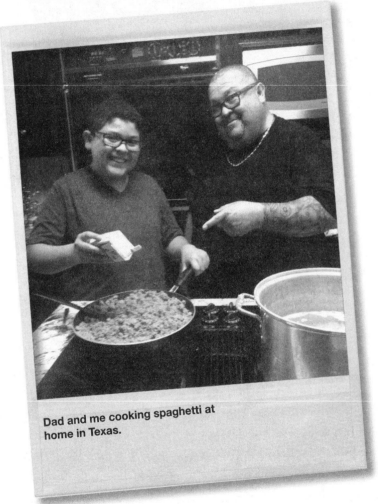

Dad and me cooking spaghetti at home in Texas.

reel life lessons . . . so far

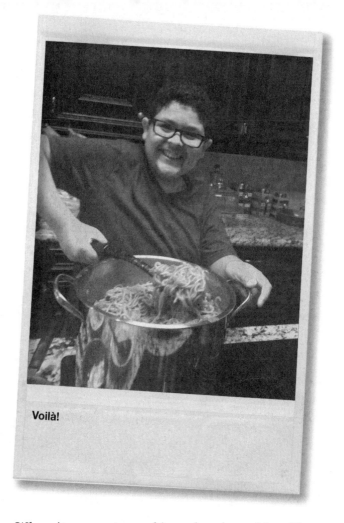

Voilà!

When it comes to cooking, there's nothing like my mom's home-style meals. My very favorite dish of hers is spaghetti with meatballs. To be honest, I like all of her cooking, so I'm never disappointed with what she makes. Whenever I am feeling a little under the weather, my mom will whip up a big batch of spaghetti, which always makes me feel better. For some reason, the spices she uses clean out my sinuses. It's better than chicken soup!

Whenever I am feeling a little under the weather, my mom will whip up a big of batch spaghetti, which always makes me feel better.

I don't get a lot of downtime these days, but when I do, I like to watch the Food Network. I've developed an interest in cooking from watching my parents and those shows. When I first got into cooking, I set out to perfect a chicken dish. Like most great food, sometimes simpler is better, and Mom's easy chicken taco recipe couldn't be easier, but trust me, it is really good. It's a perfect meal.

MY FAVORITE MEALS
THAT MOM MAKES

I thought it might be fun to share a few of my favorite family recipes with you so you can enjoy the cooking I've grown up eating and loving my entire life.

spaghetti

1 small package spaghetti noodles
1 jar of spaghetti sauce of choice
1 cup sugar
1 lb. hamburger meat
2 eggs

Boil noodles till soft.

After the noodles are soft, drain the water and wash the noodles in a strainer.

Put the noodles back into the pot.

Then in a blender, add your sauce of choice, and then add a cup of sugar and blend.

Brown the meat.

Drain excess grease from the meat.

Then add your sauce to the meat to get warm.

Start to boil your two eggs.

When your eggs are boiled, dice them and add them to the meat sauce.

Then add the meat sauce to your pot of noodles.

chicken tacos

1 package of skinless chicken thighs
½ cup of cooking oil
1 cup of white flour
1 can of tomato sauce
salt
pepper
1 tablespoon of garlic powder
yellow corn tortillas
1 package of shredded mild cheddar cheese
1 head of shredded lettuce
2 chopped tomatoes

In one big two-quart pot, add water, set stove to medium and bring water to a boil.

Add the skinless thighs and simmer for about 25 minutes until the chicken is cooked through.

Take the chicken out and let it cool down, and then debone.

Save the chicken stock in the pot. You will use it later.

In a skillet, heat the cooking oil. Then add the white flour to brown. Once the flour is browned, add about two cups of chicken stock to make a gravy. Also add tomato sauce, salt, pepper and garlic powder, and let it simmer. Then add chicken to the gravy.

Heat a small skillet with a light coating of cooking oil on medium heat. Quickly add one corn tortilla at a time to the cooking oil, turning it over to heat each side. When done, set corn tortillas on a paper towel to drain.

Finally, add your chicken and gravy to your corn tortilla, and then top with cheese, lettuce and tomatoes.

Enjoy!

reel life lessons . . . so far

peppered steak

1 bell pepper
1 package of beef stew meat
1 can of 98 percent fat-free cream of mushroom soup
salt
pepper
1 box of five-minute white rice

Add three cups of water to a frying pan and then set it on a stove at medium heat.

Cut the bell pepper into slices.

Cut the beef stew meat into small cubes, and then add to the water in the pan and let it cook for 25 minutes or until meat is soft.

Add the bell pepper slices into the pan for the last 15 minutes before meat is done.

Add the can of cream of mushroom soup, and stir.

Sprinkle with salt and pepper.

While meat is cooking, make white rice according to the box directions.

Serve over rice.

embrace your own chef rico and other talents

bean & weinie tacos

1 package of beef weiners
1 12-oz. can of pinto beans
1 8-oz. can of tomato sauce
2 tsp. of hot sauce of choice
1 package of flour or corn tortillas

Dice wieners, and fry them in a pan until they brown.
Slide them over to one side of the pan.

Open and drain the can of pinto beans, and then add the pinto beans to the other side of the pan.

Start warming up and smashing the beans in the other side of the pan.

After the beans are warmed and smashed, add the can of tomato sauce and then add hot sauce to your liking.

Stir everything together until hot.

Then put the filling into a tortilla of your choice and serve taco style.

I think it's important to know how to cook for yourself and create something—sometimes out of nothing! It's creative and artistic, so it taps into that side of my brain.

Making cupcakes to surprise my castmates on *Modern Family*.

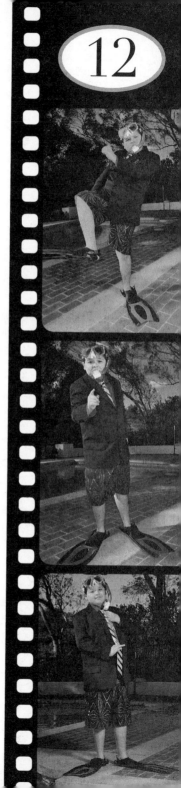

you never
know when
a chance
meeting
can
become
a lifelong
friendship

when I first started acting, I remember telling my sister that it was important to always keep your eyes open and a camera around because you never know who you might meet. We were new kids in Hollywood, so seeing anyone famous was always exciting.

One day, I was on the Warner Brothers lot going on an audition for the television show *E.R.* I was walking a few steps behind my mom and not paying much attention to things when I suddenly heard a man call out, "Hey, kid!"

I stopped cold in my tracks because somehow I instinctively knew he was talking to me. When I turned around to see who was calling out to me, my eyes opened superwide like a cartoon character's when I realized it was George Lopez. I was completely frozen and, yes, very starstruck.

"Mom, Mom, turn around." I pleaded, but she just kept walking.

"C'mon, Rico. You're going to be late for your audition," she said, without looking back or missing a step.

I knew she would be bummed out if she missed seeing Mr. Lopez, so I said, "Turn around," one more time, only this time a little louder and more demanding.

Well, that must have gotten her attention because when she turned, she clenched her fists like a schoolgirl and let out a screeching "Oh my God! It's George Lopez!"

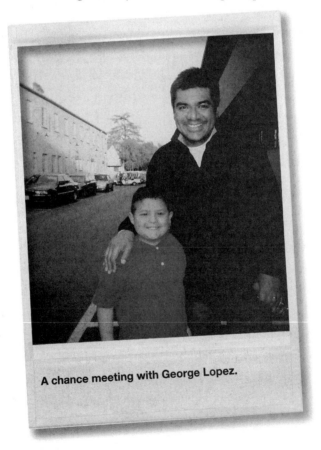

A chance meeting with George Lopez.

reel life lessons . . . so far

He handed us a couple of *Lopez Tonight* T-shirts and took a few minutes to pose for pictures. He even showed me his brand-new Bentley, which had a set of shiny chrome wheels. Even though I loved the car, I told Mr. Lopez that my dad owns a tire shop in Texas and made sure he knew I could get him a really good deal on new rims if he ever decided to change the chrome wheels he had. Of course, Mr. Lopez laughed.

Before going our separate ways,

Mr. Lopez told me to stay in school

and work super hard at my acting.

Before going our separate ways, Mr. Lopez told me to stay in school and work super hard at my acting so I could someday drive a car like his. It was a good thing I had my camera because I was able to capture that moment, which I will never forget. Best of all, I got the part I auditioned for that day too!

Well, as they say, "What goes around, comes around." A few years later, I was a guest on *Lopez Tonight*. The first question George asked me was whether I remembered the first time we met. Of course I did. We had a good laugh over that chance encounter.

When I did that episode of *Lopez Tonight*, it was just before Christmas 2009. George asked me what I wanted. An Xbox?

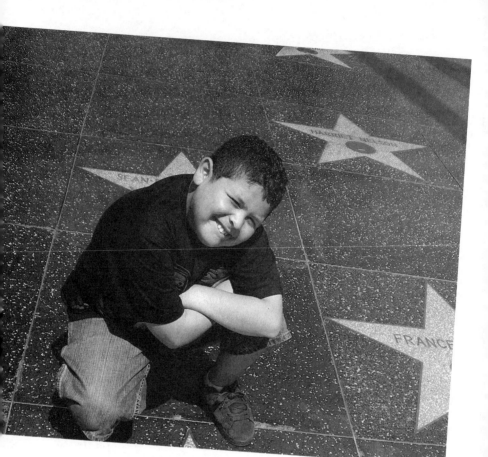

A Wii?

Guitar Hero?

Nope. What I really wanted was the fourth book in the *Diary of a Wimpy Kid* series.

Yes, a book.

I love to read and especially like books that keep the reader interested through humor. In a perfect world, I like to finish one book in a series and jump right into the next so I don't have any downtime in between reading.

In a perfect world, I like to finish one book in a series and jump right into the next so I don't have any downtime in between reading.

The *Diary of a Wimpy Kid* series deals with all of the funny stuff about growing up without all of the serious issues. I like these types of stories because they represent what so many kids my age go through, deal with and feel during our awkward middle school years. I know what it's like to feel different because of what being homeschooled means. I don't have the same connection with other kids my age that I would have if I were in a traditional school. Although I don't share the hallways with kids who are taller, meaner and some already shaving, I can appreciate what it feels like to be different. After all, I am too. Still, my world is pretty sheltered from the everyday battles of bullying, teasing and teenage angst. I think that makes me pretty lucky.

I suppose there's a wimpy kid in all of us—I know for me, I don't like being scared. I don't like spiders, bees or ants. I also understand the hazards and pitfalls of growing up early.

People tell me I'm mature for my age and wise beyond my years. I can't say whether this is true—but it would be cool if I am.

chance meeting

I suppose there's a wimpy kid in all of us.

What I do know is that I have been truly blessed to grow up in a family that gives me a strong sense of security through unconditional love and support of everything I want to do or become. My parents show me the meaning of courage by teaching me to believe in myself. Christmas came early for me in 2009. Much to my surprise, at the end of my interview, Mr. George Lopez reached into a hidden bag and pulled out the new *Diary of a Wimpy Kid* book and gave it to me as an early Christmas present. I was really surprised and very happy because I couldn't wait to find out what happens next in the story.

I was so happy to receive such a thoughtful and memorable gift from someone like George Lopez, a man I respect and admire.

I was so happy to receive such a thoughtful and memorable gift from someone like George Lopez, a man I respect and admire. A great gift isn't about how much you spend as it is about the thought, and it was really special

to know that he cared enough to give me something as important and meaningful as that book.

Dear Journal,

I thought it was really cool when I met George Lopez a few years ago, and now that chance encounter has come full circle. Someone I grew up watching on TV, I now get to call friend.

chance meeting

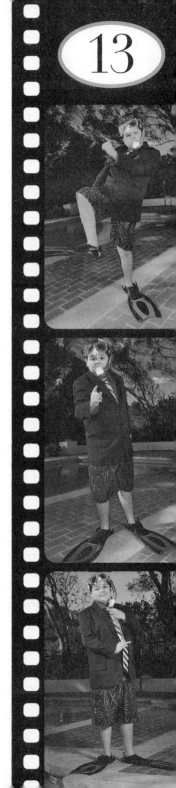

life isn't
a dress
rehearsal!

my parents have held all of their children to a high standard from the very start. To me, their expectations are reasonable and are really no big deal because that is how I have always lived. For example, my dad has always insisted that his children are well dressed and never seen in public looking messy. When I was younger, I remember my dad used to match his shoes to his shirt—something that made him feel pulled together. That habit has definitely rubbed off on me because I do the same thing. I also

make it a point to always wear a watch, a nice necklace and a fedora or newsboy-style hat to complete my polished look. I think it's important to look your best, or as my dad likes to say, "*Dress for success* because life isn't a dress rehearsal."

DRESS FOR SUCCESS because life

isn't a dress rehearsal.

Dressing for success at my first red-carpet event for the short film *Los Tamales*.

For as long as I can remember, I have always been known as Rico Suave. I guess it's because of the famous song, but I really like to dress well, so the name has never bothered me. (Let's be clear: if we should ever meet, you can call me Rico...*Suave*!)

I remember being at my dad's tire shop when a sixteen-year-old kid came in looking for a summer job. When he walked into the store, his pants were so baggy that they were falling below his hips. I knew he was just trying to be cool, but my dad didn't like that look at all. He told the kid that if he was serious about wanting to

164

work at this shop, he needed to put on a belt—and fast. He said to find a rope or an extension cord so he could tie his pants up over his waist. The kid grabbed the first thing he could find to use as a belt and came back looking slightly more professional.

Although my dad didn't approve of the baggy look from a fashion perspective, he was also concerned that loose pants could be a safety issue in the garage. Someone who is constantly pulling up their pants is in no position to handle heavy machinery or tires. The kid proved to my dad that he was sincere about wanting the job and worked for our family for the entire summer.

Here I am wearing my signature-style hat, with my niece Zoe.

Here with my niece Reagan.

While I don't see myself as a fashion trendsetter, I do have a passion for nice clothes. These days, I am fairly recognized for my trademark love of hats, especially Kangol hats, which I enjoy wearing backward. You don't see a lot of people wearing hats on the red carpet.

life isn't a dress rehearsal!

> *I don't really have any fashionable people that I model my style after. I just wear what I think looks good.*

I don't really have any fashionable people that I model my style after. I just wear what I think looks good. Red is my favorite color because it is highly visible and really stands out. I prefer bright reds to the darker shades. My second favorite color is green because it reminds me of the Incredible Hulk. Our family's favorite color is purple or, as we like to call it, "power purple." The right shade of purple can really stand out. I mostly stay away from prints and stick to solid colors. My sister, Raini, on the other hand, really works the patterns. Leopard print, tiger stripe, you name it, and she can rock it!

I love high-tops because I like to wear long socks, and the sneakers nicely cover them. If I wore low-top sneakers, my socks would come up *way* too high. I also love vests because they look cool and are much more interesting than jackets. Some of my favorite stores to shop at are American Eagle Outfitters, Forever 21 Men and Gap. Their clothes are comfortable. I've found that it is nearly impossible to look good if I am not comfortable.

As I mentioned previously, my dad loves to match his shoes with his shirt, and that style has been passed down to my brothers and me. It's actually pretty easy because if I know the shirt I am wearing, then I immediately know

Mi familia **looking our best!**

the shoes to wear. And if I know the shoes, then I know the shirt.

Once in a while, I like to accessorize. There are a few necklaces that I like to wear, like my one of the state of Texas complete with a lone star in the middle. There is another of a Ping-Pong paddle and ball that says "Player." Even though I don't play Ping-Pong, I still like the necklace.

I wear watches whenever I can. My brother Poppi collects Casio G-Shocks. One day, while we were Christmas shopping, we stopped at a kiosk where watches were sold. When we were done, we went back to the car and began packing our stuff into the back. Poppi realized that he

life isn't a dress rehearsal!

had forgotten a present for his wife, Amy, so he headed back into the mall while I waited in the car.

When Christmas morning came, I found myself unwrapping an amazing G-Shock watch. It was then that I realized that Poppi didn't go back into the mall to get a gift for his wife at all. He rushed back in to buy the watch to give to me. I wear it whenever I am wearing red.

Dear Journal,

Mom is a trained hairstylist, and I love the way she cuts my hair. If I didn't cut my hair, it would get really bushy and full. When my dad was my age and into his teens, he had an Afro. When I grow my hair out, it gets really big—like an Afro too!

When I first auditioned for the role of Manny in *Modern Family*, my hair was a lot fuller than I wear it on the show. Eventually, I gave in and let my mom cut it short like the rest of the guys in our family like to wear it. Mom is the only person on the planet who can actually tame my beastly hair! She has taken on the role of my personal hairdresser over the years because she knows just how I like it. Maybe someday I will help her open her own beauty shop!

there is no shame in being a self-confessed mama's boy

for as long as I've been acting, I have been very lucky to be paired with really great actresses playing my mom. It could be worse—I could get the roles with a wicked mom, right? Naturally, people are curious about how my real mom feels about me having a TV mom. They want to know if she likes how my TV mom treats me. My mom and Sofia Vergara get along great. It's kind of funny when people ask me about Sofia because they stumble over their words. Sofia has that effect on some people. Okay,

most people. I always tell them the truth: Sofia is a really nice person, and she treats me as if I were her own son.

> For as long as I've been acting, I have been very lucky to be paired up with really great actresses playing my mom.

While we were filming our season one wrap episode in Hawaii, there was a dinner scene in which I just happened to be sitting next to Sofia. Although the director usually tells us not to eat the bread, I usually go ahead and do it anyway. You're not supposed to eat the props! I usually peel off the crust before eating the bread because I like the inside part better. Sofia asked me why I was doing it, so I went about explaining the reason to her—it was mainly because I wanted to get to the soft bread inside.

Sofia suddenly interrupted me. "Leprechauns?" she asked in her very thick Colombian accent.

"Aye," I said, rolling my eyes.

For some reason, while I was explaining why I took the crust off the bread, she thought I was saying something completely different. It was out of nowhere because nothing of what I was saying had anything to do with leprechauns! We both busted out laughing at the table and never forgot about that moment.

reel life lessons . . . so far

I go out of my way to hold the door open for others, help someone cross the street and assist those in need. Not long ago, my sister and I were at a local drugstore. As we were leaving, I noticed an elderly woman with a walker slowly making her way toward the door. The woman stopped and tried to hold the door for us. I quickly pushed the door and held it open from my side. I told the woman that she didn't have to hold the door for us, that we would hold it open for her so she could come into the store. She told us that most people would have let the door go and let it hit her. I could never allow that to happen.

> I am not perfect and I am certainly not an angel. I'm just a boy whose mother cared enough about him to show him the way to treat others.

Look, I am not perfect and I am certainly not an angel. I'm just a boy whose mother cared enough about him to show him the way to treat others. My mom teaches me the importance of making the right decisions. If you're raised the right way, these choices become habit. Thankfully, I

It's so important to respect all people. Some people confuse my kindness for weakness. That would be their mistake because I don't think being respectful makes me a wimp. On the contrary, it makes me strong and secure.

My parents instilled good values and strong self-esteem in all of their children—some things I hope to share and pass on to my own kids someday. Being disrespectful is just wrong. It doesn't sound right and isn't how I want to walk through life. We all live in a world where we get what we give. If you are mean to someone, you can bet that person will be mean to you. And if you're kind to someone and you still get meanness back, well, at least you know you tried your very best and can walk away with your dignity. You have a better chance of winning by being nice.

You have a better chance of winning by being nice.

there is no shame in being a self-confessed mama's boy

Dear Journal,

Since dad isn't always around, I sometimes feel like I have to be the man of the family. If our cable goes, I know how to fix it. If Mom's computer goes haywire, I know how to get it working again too. And when I want to do something extra sweet for her, I'll go and find her favorite candy, Tootsie Rolls, give her a handful and bust out my own version of the hip-hop song "Tootsie Roll."

When I am called to the set to do a scene, I make sure I give my mom a hug and a kiss before taking my mark, and I always tell her I love her. Even from across the stage, I want her to know she is right there with me, by my side. She is so thoughtful and kind. She has taught me so much and continues to teach me things every single day that I will carry with me for the rest of my life, such as the importance of good manners, never being rude and not talking back to anyone. It's so important to respect all people. Some people confuse my kindness for weakness. That would be their mistake because I don't think being respectful makes me a wimp. On the contrary, it makes me strong and secure.

I find great comfort in knowing

that my mom still loves me even

when I make a mistake.

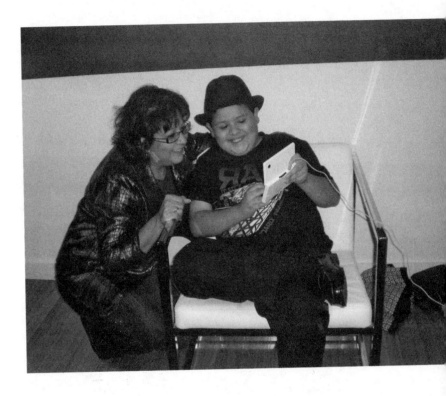

She isn't just a mother, to me—she is

the greatest woman alive.

there is no shame in being a self-confessed mama's boy

The ultimate trip to the movies was a bit my mom and I did for the 2012 Oscars. My mission was to watch all nine of the movies nominated for Best Picture. So Mom and I cleared an entire day so we could go watch all of the movies together. We took a ride to Santa Monica, where there are several movie theaters next to one another, so we could take each one in. I don't think Mom or I have ever had so much popcorn and soda in one day. In fact, we ate so much popcorn, we were sweating butter!

If I get into trouble, Mom is there to teach me right from wrong.

If I get into trouble, Mom is there to teach me right from wrong. And even though she likes to agree with my dad on issues, I find great comfort in knowing that my mom still loves me even when I make a mistake. She worries about everything, so we don't have to. Mom does so much and never complains. Even though we know Mom misses Dad, she never says a word about being away from him. While she is having to spend her days with my sister or me on the set, driving us around, taking care of us when we are sick and anything else she does for us—and, believe me, she does *everything*—we know Dad is always on her mind, so we do our best to make her job easier. She isn't just a mother, to me—she is the greatest woman alive.

reel life lessons . . . so far

loved. I think it's cool that we still want to hang out and do things like watch TV or go to the movies together.

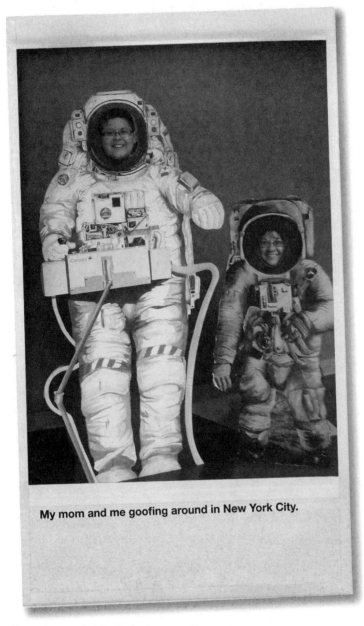

My mom and me goofing around in New York City.

there is no shame in being a self-confessed mama's boy

Over time, it has become a running joke between us. Every now and then when we are joking around on the set, I say, "Leprechaun," and Sofia immediately starts laughing hysterically. Something about the moment just gets both of us every single time.

Sofia's favorite candy is Hot Tamales and marshmallows. She likes to stash them in drawers all around the set. She always has a handful and starts eating them on set. It is almost as if she wants me to enjoy them as much as she does.

"Here, Rico," Sofia says, holding out a handful of Hot Tamales for me.

"No, I'm okay right now," I answer.

"No, *here*," she repeats, pushing the candy into my hand.

Sofia doesn't like to take no for an answer.

In my eyes, I have two wonderful moms. Both amazing women who love me very much. That makes me so lucky.

Naturally, *I* am *that* young man who thinks his mom is the best mom in the whole wide world.

I am THAT young man who thinks his mom is the best mom in the whole wide world.

174

Since I was a toddler, my mom blesses me before I go to sleep. That's our thing, and it makes me feel safe and

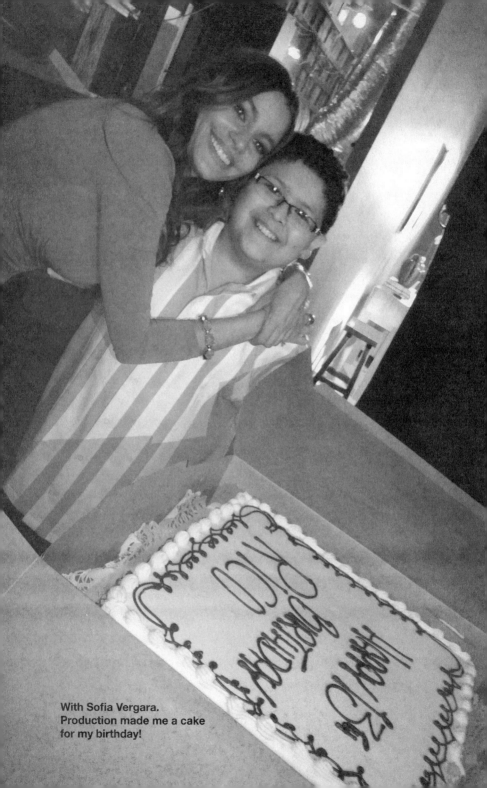

With Sofia Vergara.
Production made me a cake
for my birthday!

don't be
afraid to
be you!

i've come a long way from being that shy kid hiding behind my mom, but there are times I can still be a little self-conscious—especially when someone asks me to dance. Don't get me wrong—I love to bust a move but in the privacy of my own home. People have told me I can dance. I don't know if it is true, but I do know I enjoy doing it.

I attended a Harlem Globetrotters basketball game where I was called out onto the court to toss up some free throws. I was so nervous to be in front of the ten thousand Globetrotter fans, who were all graciously cheering me on. After I missed ten shots, one of the Globetrotters

picked me up and carried me to the hoop so I could make a basket. I still missed the shot!

All of the players fell to their knees to pray for me. I needed all the help I could get. I finally sank a ball, but it wasn't easy.

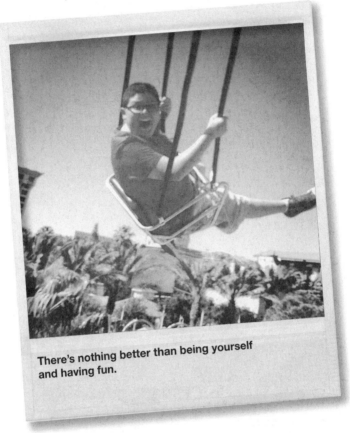

There's nothing better than being yourself and having fun.

I have a tendency to feel really good about myself and happy with my performances when my parents and my sister are around to tell me how I did. I will ask them to give

reel life lessons . . . so far

me a grade, and they will always be honest with me. After myself, Mom, Dad and Raini are my three biggest critics. If they tell me I did well, then I know I knocked it out of the park. And, to be fair, if they tell me I could have done better, you can bank that there was room to improve.

Mom, Dad and Raini are my three biggest critics. If they tell me I did well, then I know I knocked it out of the park. And, to be fair, if they tell me I could have done better, you can bank that there was room to improve.

Look, it's important to have a gauge in life that measures how we are doing. We all have people in our lives that tell us what we want to hear, but so few tell us the things we need to know. It's so important to have at least one person you can go to and ask to be honest with you, regardless of the outcome. It's just as important to make sure you remain open to hearing whatever it is that person has to say.

We all have people in our lives that tell us what we want to hear, but so few tell us the things we need to know.

This isn't a dress rehearsal—this is the real deal. We get one shot to put our best foot forward, and you'd better believe I will take that chance every single time. Thankfully, I know what is expected from me, so I go into every single situation prepared and ready to roll. I may get to act for a living, but it's still a job that someone else is paying me to do. The boss wants his or her money's worth and is counting on me to deliver, so I better bring my A-game each and every time or I won't be working very long.

I may get to act for a living, but it's still a job that someone else is paying me to do. The boss wants his or her money's worth and is counting on me to deliver, so I

better bring my A-game each and

every time or I won't be working

very long.

I am seriously committed to my craft and, therefore, understand I can have fun doing my job as long as I am getting things done. I have no plan to stop doing what I am doing now. My parents have always taught me to show up, be professional and remain true to my word. That's what they showed me as their secret to success.

My parents have always taught me

to show up, be professional and

remain true to my word. That's

what they showed me as their

secret to success.

And as prepared as I am when I show up to the set, sometimes things happen you just can't see coming. I guess it's true when people say, "Life happens."

There was one particular day on the set of *Modern Family*

when the scene called for me to carry a large box in front of me. The shoes I was wearing were brand-new, and therefore, the soles were slippery. The scene called for me to run up a flight of stairs carrying the big box so I could open it in my bedroom.

The director called, "Action!"

I set out to do the scene as written. I began running up the stairs when I suddenly slipped and fell onto my side.

To be fair, people have fallen on those stairs many times. It just so happened that I was the next victim. Although I wasn't hurt, my pride was a little bruised.

The next take we did was perfect. I thought I was out of the woods until the director said he wanted to do the scene one more time.

Hmph!

This time I made it up the stairs, past the point where I fell and was off-camera as Sofia and Ed started their dialogue. Just as they began talking, there was a loud boom from the top of the stairs.

You guessed it.

It was little ol' me falling—again.

I am not a clumsy guy nor am I terribly accident-prone, but I managed to slip and fall a grand total of three times that day. The whole experience was extremely out of place for me because while I am a joker, I am not a prankster. I was worried that my coworkers might have thought that I was fooling around and acting childish.

I wasn't.

Thankfully, everyone was very understanding.

I was able to get through the day but not without a bruise or two—let alone a slightly beaten ego.

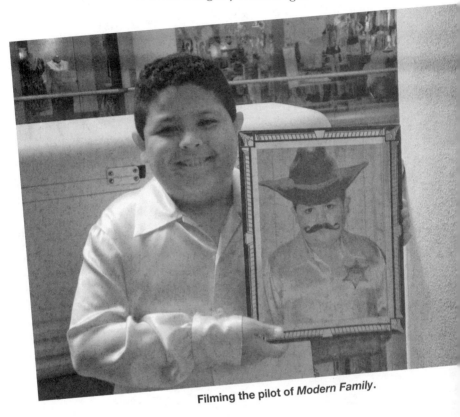

Filming the pilot of *Modern Family*.

The important lesson I took away from that day was you can't beat yourself up along the way. If you aren't your own cheerleader, then you become your worst opponent. From what I can see, life can be hard enough. Don't be the person stopping yourself before you ever get off the bench. Believe in yourself, and I promise you can do anything.

191

Don't be the person stopping yourself before you ever get off the bench. Believe in yourself, and I promise you can do anything.

home is
where
your family
lives and
where you
can be
yourself

acting has had several profound
impacts on my life, but the most surprising
has been my newfound sense of indepen-
dence, especially now that I've entered my
teenage years. My dad still likes it when he
or my mother accompany me to places so
they can keep any eye on me, but they're
getting used to the idea that I can do some
things on my own. Auditioning has become
more fun and interesting because this is an
opportunity for me to meet other kids who
are pursuing the same passion that I am. It's

cool to see how different casting directors approach each part and the slight variations in the process. Acting has taught me to be more disciplined than I ever thought I'd be at this age. I go to bed early because I often have to be at the studio for a seven a.m. call time. That means I have to get up by five thirty to get there on time, and I don't want to show up grumpy and tired. I want to be professional on the set, which means always being respectful and kind. I don't mind the discipline part of the job because I feel it is preparing me to go out there and deal with situations I may face along the way.

> Acting has taught me to be more disciplined than I ever thought I'd be at this age.

Another great life lesson I've learned through my "reel" life is the true meaning of patience. Sure, the waiting around can get boring and tedious, but it's just something that comes with the job. You wait to hear your name called at an audition, and then you have to wait to see if you got the job. Then once you have the job, there's a lot of waiting around on the set while cameras and lights are being set or last-minute changes are being made to the script. It's a big "hurry up and wait" situation. I have learned a tremendous amount from all of the waiting. When it comes to acting—and I suppose life—nothing comes easy.

reel life lessons . . . so far

I go into every audition with a mind-set as if the role is already mine. I am that character before I get in front of the decision makers. I hope for the best and accept that I won't get every role I try out for.

> I hope for the best and accept
> that I won't get every role I try
> out for.

I can imagine that sports teams are coached to approach each game they play in the same way. They're in it to win it. What's the point of going out onto the field or court with an "I'm going to lose anyway" attitude. This connection between acting and athletics became crystal clear after I attended my very first Texas A&M football game in the fall of 2011. Now, even though I grew up in the same town as the college, I had never been to one of their games.

I was really excited when my uncle called to see if he could take me to an Aggie game when I came back to Texas to celebrate Thanksgiving that year. He had arranged for some really good seats inside the world-famous Kyle Field. My dad wanted to come too, so the three of us had a true guys day out.

When we got to the field, we had to walk up a series of ramps until we got to the level where our seats were. Before sitting down, we grabbed some burgers and chips

197

from the concession stand, along with the largest soda I'd ever seen. I didn't really want to drink so much, but they gave it to us anyway. It was a good thing we were seated near a bathroom!

At the same time, my mom and sister were flying in from Los Angeles. Throughout the game, Dad and I kept checking their flight to make sure they were on time. We wanted to be home by the time they walked through the door. It was an especially windy day, so I think my dad was a little worried they might get delayed or worse—canceled. It had been a while since Raini had been on a plane, so I was concerned it might be a bumpy and scary flight for her. Thankfully, they landed safe and sound, so we could focus on enjoying the rest of the game.

The stadium was packed with more than eighty-six thousand fans, all there to watch the Aggies beat the University of Kansas Jayhawks. Now, Eric Stonestreet who plays Cam on *Modern Family* is from Kansas, so he bragged that his team would beat mine. Technically, Eric is a fan of Kansas State University, but Texas A&M was still playing a team from Kansas, so it was a war nonetheless.

About halfway through the game, my dad noticed that the crowd began to yell and scream. We had heard former President George W. Bush was in the crowd that day, so we assumed the crowd was clapping for him—that is, until I looked up on the Jumbotron screen and saw...me! I couldn't believe I was up there, and it was kind of thrilling to have that happen.

I love when fans approach me for a picture or an autograph. They mean the world to me because they love and support my work on *Modern Family*. After all, without the fans, there would be no television show! If you don't appreciate your fans, they aren't going to want to watch you. I am a natural-born people pleaser, so I like to make everyone happy, whether they are members of my own family or fans of the show.

The craziest encounter I've had with a fan happened as I was coming out of the Billboard Music Awards in Las Vegas. I was walking with my parents to have dinner in the hotel food court when I noticed a girl walk by and give me a quick glance. A moment later, she came back up to me.

"Aaahhhhhhh!" she screamed. "Oh my *God*! It's Manny!"

I don't think I've ever heard anyone yell that loud! She continued screaming until her friends came, and then they all began screaming at the tops of their lungs. It was wild. The next thing I knew, there was a giant crowd of people around me asking for

photos and autographs and freaking out over me. I had never had that experience before, and it made me feel so good.

Occasionally, people get so caught up in the moment of seeing someone who is on television that they say the craziest things. They have invited me back to their house! I respectfully decline. Still, I try to please everyone. But I do have to go home at some point and go to bed. Because we have so many different types of characters on *Modern Family*, our fans are all different types of people. The show appeals to a very wide audience, even a stadium full of football fans!

I really got into the spirit of the game that day, cheering and applauding with all of the die-hard fans who were all around me. Every time A&M scored a touchdown, everyone in our section locked arms and rocked back and forth singing the Texas A&M fight song. Total strangers holding on to one another, sharing a common interest is something I'd never experienced. Even though we were all strangers, it was as if we were all at home during that football game. It was awesome. Even better was that A&M beat Kansas 56-7! Eric Stonestreet was a little crushed by the defeat, but I enjoyed every moment of my first college football game.

reel life lessons ... so far

As I watched the game, I saw guys from both teams rushing into one another, trying to break through the defensive lines or taking the offensive and trying to score a touchdown. If the players fell down, they got back up and brushed themselves off. If the home team scored a touchdown, the opposing team went into a huddle to discuss strategy and just went right back onto the field to try again. And that's what it feels like as an actor: you get knocked down a lot, but you have to always get back on your feet and try again, always keeping those goalposts in mind. It's true that I accept the idea that I won't score every acting job I try out for, but you can bet that I'll do everything in my power to be the best I can be.

I accept the idea that I won't score every acting job I try out for, but you can bet that I'll do everything in my power to be the best I can be.

My dad has taken me to most of my "firsts" in life, including my first baseball game in Dayton, Ohio, to see Dayton's farm team, the Dragons. I actually got to operate the scoreboard during that game. There's really nothing like a father-son experience. Our house in Texas has a

home is where your family lives

pond full of catfish. I was around ten years old when I asked my dad to teach me how to fish. He showed me how to put the hook on the line, bait it, cast and reel—and most of all to have patience—the key to fishing. We never eat what we catch because we feel so attached to our fish! But boy, do we love a good catfish dish. I have no problem at all ordering it in a restaurant.

My dad is the single most important influence in my life, especially these days as I am transitioning from boy to young man. Being away from my dad has gotten harder as I get older. I need my dad to be there for me—and he is. Whether I call him on the phone or spend a really special day watching football with him, I can talk to him about anything and get his man's point of view. I really respect what he has to say because I know he has been through everything I am going through—and then some. No matter what I am going through, Dad always assures me that things get better with time.

> I really respect what he has to say because I know he has been through everything I am going through—and then some. No matter what I am going through, Dad always assures me that things get better with time.

reel life lessons . . . so far

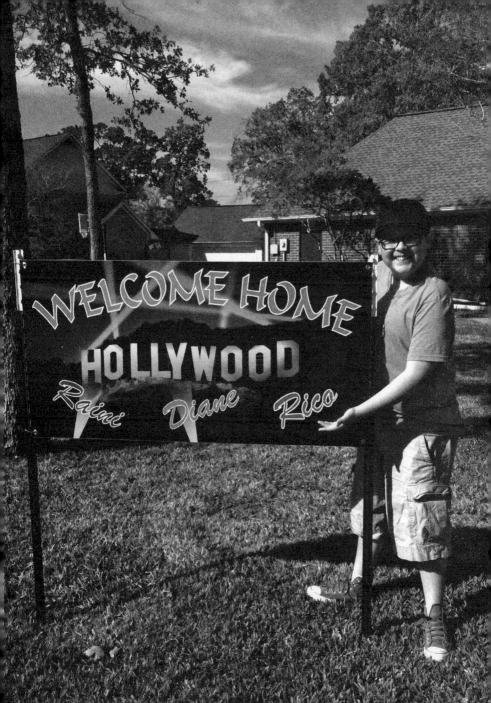

Dad welcomes us to our new home in Texas.

It is really hard for me to believe that I have lived in Los Angeles longer than in Texas. The first time it occurred to me was when I referred to California as "home."

I remember someone in my family made the comment, "Home? Texas is your home!"

And they were right. I hail from Texas, but L.A. is where I live.

This got me thinking about what makes a home.

To me, a home is where your family lives. It's where you feel safe, comfortable and completely content. It's a place you can kick your feet up, relax and breathe. It's where you can decompress, let your guard down and just be yourself.

> To me, a home is where your family lives. It's where you feel safe, comfortable and completely content. It's a place you can kick your feet up, relax and breathe. It's where you can decompress, let your guard down and just be yourself.

When I first moved to the West Coast, I came with a double-barrel loaded Texas accent. I said things such as

"y'all" and "fixin'" as in "I'm fixin' to make some pancakes, would y'all like some?" You might say I was more countrified than anything else. I worked on losing the drawl, but I find it comes back awfully quick when I am on the phone with my family or when I'm back in Texas.

Although I love my family dearly, there will be a day in the not so distant future when I will leave the nest and live on my own and I won't depend on them anymore. As hard as that fact is to imagine, the truth remains that day will come. I hope that I will remain a credible and working actor for years to come because I love it so much. Maybe I'll even get a chance to do some work behind the camera too. I like the process of putting things together, so I want to continue to learn as much as I can about directing, editing and lighting.

> Although I love my family dearly, there will be a day in the not so distant future when I will leave the nest and live on my own and I won't depend on them anymore.

When I am on the set of *Modern Family,* I will spend my downtime asking the sound man or lighting director as many questions as I can think of so I can understand ev-

erything that goes into putting together a television show. As an actor, I couldn't ask for a better opportunity to learn all sides of the craft than I get on *Modern Family*. And while I plan to someday attend college—maybe even Texas A&M—there's no better education I could be getting than living my life as I do right now.

reel life lessons ... so far

some final thoughts

when my publisher came to me and asked if I'd like to write a book, I had no idea what I was getting myself into. After all, I'm just a kid who didn't think he'd lived enough life yet to fill a whole book! But as I got started on this journey, I came to realize I really have gone through so much in such a little amount of time. Talking about that shy little boy hiding behind my mom's pant leg feels like someone else's life—and yet it's not! It's me.

You can't really know where you're going without understanding where you have been.

I am really proud of my heritage and where I come from. After all, you can't really know where you're going without understanding where you have been. And now that I have had the opportunity to reminisce about some of my life experiences, I've come to realize it's been a pretty darn good journey so far.

I guess you could say that I am living proof that having the courage to follow your dreams can get you really far. I mean, c'mon, I came from a small town in Texas. Things like this don't happen every day. And still, it happened to me and my sister too!

I am living proof that having the courage to follow your dreams can get you really far.

I owe so much to parents for their sacrifices and their love and support that allow me to keep going every day.

And without my faith in God and the blessings He has given me, I wouldn't be doing what I love to do the most—entertain!

Thank you for taking the time to read my book and learn about my life and how it's been...so far!

<div align="right">

Rock on!

—Rico

</div>

some final thoughts

acknowledgments

First, I want to thank my parents for everything they've given up to give to me.

To my siblings, Poppi, Ray and Raini for always being there and supporting me in everything I do.

To my nieces and nephew—you each make me so proud every single day.

To my grandmas and grandpa—I want to thank you for all of your unconditional love.

And to the rest of my family—and you know who you are, you rock!

To my *Modern Family*...family, I couldn't ask to be on a better TV show than working with all of you! I learn so much each and every day—thank you for everything!

To my Team Rodriguez:

To Susan Osser, my amazing manager who believed in me from the start.

And to my agents, Philip Marcus, Bonnie Ventis and Jody Alexander, who also believed in me from the very beginning.

And to my attorney, Jeffrey Osser, and everyone who supports our team—thank you for your endless hard work and dedication.

To my awesome writer, Laura Morton, who put my words on paper—you are the best!

To my publishing family—Raymond, Kim and their entire team who helped bring this book to life! Thanks for believing in this project.

And finally, I want to thank God for His blessings.

acknowledgments

about the author

rico rodriguez plays Manny Delgado on the ABC sitcom *Modern Family*. He has won numerous awards and accolades, including a Screen Actors Guild Award for Best Ensemble in a Comedy Series, which he shares with the rest of the cast, as well as Breakout Male at the 2010 Teen Choice Awards. He was also featured on the cover of *Entertainment Weekly* as one of their 2010 Entertainers of the Year and hosted the Red Carpet Live for the 2011 Oscars.

Follow Rico on Twitter at twitter.com/#!/StarringRico.